D0722289

THE LANGUAGE OF THINGS

THE LANGUAGE OF
THINGS

understanding the world of desirable objects

DEYAN SUDJIC

WITHDRAWN

W. W. NORTON & COMPANY

NEW YORK LONDON

Copyright © 2009, 2008 by Deyan Sudjic
First American Edition 2009

First published in Great Britain in 2008 by Allen Lane, an imprint of Penguin Books

All rights reserved
Printed in the United States of America

For information about permission to reproduce selections from this book,
write to Permissions, W. W. Norton & Company, Inc.,
500 Fifth Avenue, New York, NY 10110

For information about special discounts for bulk purchases, please contact
W. W. Norton Special Sales at specialsales@wwnorton.com or 800-233-4830

Manufacturing by RR Donnelley, Crawfordsville, IN
Book design by Ellen Cipriano
Production manager: Andrew Marasia

Library of Congress Cataloging-in-Publication Data

Sudjic, Deyan.
The language of things : understanding the world of
desirable objects / Deyan Sudjic. — 1st American ed.
p. cm.
"First published in Great Britain in 2008 by Allen Lane."
Includes bibliographical references and index.
ISBN 978-0-393-07081-1 (hardcover)
1. Design—Philosophy. 2. Design—Social aspects. I. Title.
NK1505.S83 2009
745.401—dc22
2009009726

W. W. Norton & Company, Inc.
500 Fifth Avenue, New York, N.Y. 10110
www.wwnorton.com

W. W. Norton & Company Ltd.
Castle House, 75/76 Wells Street, London W1T 3QT

1 2 3 4 5 6 7 8 9 0

CONTENTS

INTRODUCTION

a world drowning in objects

NEVER HAVE MORE OF US HAD MORE POSSESSIONS THAN WE DO now, even as we make less and less use of them. The homes in which we spend so little time are filled with things. We have a plasma screen in every room, displacing state-of-the-art cathode-ray-tube-based television sets just five years old. We have cupboards full of sheets; we have recently discovered an obsessive interest in the term 'thread count'. We have wardrobes stacked high with shoes. We have shelves of compact discs, and rooms full of game consoles and computers. We have gardens stocked with barrows and shears and cutters and mowers. We have rowing machines we never exercise on, dining tables we don't eat at, and triple ovens we don't cook in.

We fill our kitchens with electric appliances, dreaming of the domestic fulfilment that we hope they will bring. Just as when fashion brands put their names to children's clothes, a new stainless steel kitchen allows us the alibi of altruism when we buy it. We are secure in the belief that these are not indulgences but investments in the

family. Our children have actual toys: boxes and boxes of them that they discard within days of acquiring. And, with childhoods that grow shorter and shorter, the nature of these toys has also changed. McDonald's has become the world's largest distributor of toys, almost all of them branded merchandise linked to a film.

Nor have our possessions ever been bigger. They have swelled to match the obesity epidemic that afflicts most Western cultures. In part it is the result of what is known as product maturity. When every household that is ever going to buy a television set has done so, all that is left for manufacturers is to persuade owners to replace their old sets by inventing a new category. Sometimes it's a miniature version, but, preferably for the manufacturer, it will be bigger and so better than the previous designs. As a result TV screens have gone from 28 inches to 60 inches. Domestic ovens have turned into ranges. Refrigerators have become bloated wardrobes.

Like geese force-fed grain until their livers explode, to make foie gras, we are a generation born to consume. But geese panic at the approach of the man with a metal funnel ready to be rammed forcibly down their throats, while we fight for a turn at the trough that provides us with the never-ending deluge of objects that constitute our world. Some of us camp outside Apple stores to be the first to buy an iPhone. Some of us pay any price to collect replicas of running shoes from the 1970s. The intricacies of model numbers, provenance and pedigree sustain a drooling pornography that fetishises sunglasses and fountain pens, shoes and bicycles, and almost anything that can be traded, collected, categorized, organized and ultimately possessed and owned.

The long boom that came to such an abrupt end has left us queasy at its excesses and the avalanche of products that threaten to overwhelm us. But governments have reacted to the threat of a slump by reminding their citizens of their duty to consume more to restart stalled economies. We are in the grip of millenarian anxiety about the

doom that faces us if we go on binge flying. Yet even the return of the selling of indulgences, a practice abandoned by the medieval church, now resurrected in the form of carbon offset payments, is not stopping us from changing cellphones every six months.

In my own life, I have to acknowledge that I have been both transfixed and fascinated by the glossy sheen of consumption while at the same time becoming nauseous with self-disgust at the volume of what we all consume, and the shallow but sharp emotional tug that the manufacture of want has on us.

Objects, so many people believe, are the unarguable facts of every-day life. Dieter Rams, who for two decades was head of design at Braun, the German consumer electronics company, certainly did. He used to describe Braun's shavers and food mixers as English butlers, discreetly invisible when not needed, but always ready to perform effortlessly when called upon. Such things have become rather more than that.

'Clothes, food, cars, cosmetics, baths, sunshine are real things to be enjoyed in themselves,' John Berger claimed in *Ways of Seeing* (1972), the best-read contemporary analysis of visual culture to be published in the past half century. He made a distinction between 'real' objects and what he saw as the manipulations of capitalism that make us want to consume them. 'It is important . . . not to confuse publicity with the pleasure or benefits to be enjoyed from the things it advertises,' he argued. Publicity begins by working on a natural appetite for pleasure. But it cannot offer the real object of pleasure.

Berger wrote *Ways of Seeing* from an uncomfortable vantage point halfway between Karl Marx and Walter Benjamin. His book was an attempt to demolish the conventional tradition of connoisseurship, and to establish a more political understanding of the visual world.

Publicity is the life of this culture [the culture of capitalism] – in so far as without publicity capitalism could not survive – and at the same time publicity is its dream.

Capitalism survives by forcing the majority, whom it exploits, to define their own interests as narrowly as possible. This was once achieved by extensive deprivation. Today in the developed countries it is being achieved by imposing a false standard of what is, and what is not desirable.

But, even before the collapse of Communism and the explosion of the economies of China and India, understanding objects was more complicated than that. It is not just the imagery of advertising that is marshalled to manufacture desire. The 'real' things that Berger regards as having authentic qualities – the car with a door that shuts with an expensive click, and which evokes a 60-year tradition in doing so, the aircraft that integrates fuel efficiency with engineering elegance, and which makes mass tourism possible – are themselves susceptible to the level of analysis that he applies to the late portraits of Frans Hals and to Botticelli's allegories. They are calculatingly designed to achieve an emotional response. Objects can be beautiful, witty, ingenious, sophisticated, but also crude, banal or malevolent.

If he were writing *Ways of Seeing* today, what Berger calls 'publicity' might just as well have been described as 'design'. Certainly there is no shortage of those who have come to understand the word in as negative a way as Berger saw publicity.

Overuse of the word 'designer' has rubbed it clean of earlier meanings, or left it as a synonym for the cynical and the manipulative. Bulthaup, a German kitchen manufacturer whose products are essential props in any design-conscious interior, even avoids the use of the word 'design' in any of its advertising. Nevertheless the design of objects can offer a powerful way of seeing the world. Berger's book belongs to a crowded literature of art. However, since Roland Barthes wrote *Mythologies* in 1957, and the imprecisions of Jean Baudrillard's *The System of Objects*, first published a decade later, few critics have subjected design to the same close analysis. It is an unfortunate gap.

The architectural historian Adrian Forty comes close to Berger's point of view with his book *Objects of Desire* (1986). But now that the world of objects has erupted so convulsively, spraying product unstoppably in every direction, there is a quantitatively and qualitatively different story to tell from the conventional narrative of the emergence of modernism as the *deus ex machina* to make sense of the machine age.

Both Barthes and Baudrillard were strikingly uninterested in any discussion of the role of the designer, preferring instead to regard the disposition of things as the physical manifestation of a mass psychology. Baudrillard, for example, professed to see the modern interior not as the product of design as a creative activity, but as the triumph of bourgeois values over an earlier, earthier reality:

> We have more freedom in the modern interior, but this freedom is accompanied by a subtler formalism, and a new moralism. Everything now indicates the obligatory shift from eating, sleeping and procreating, to smoking, drinking, entertaining, discussing, looking and reading. Visceral functions have given way to functions determined by culture. The sideboard used to hold linen, crockery or food. The functional elements of today house books, knick knacks, a cocktail bar or nothing at all.

But this is special pleading from a boulevardier. Rather than repressing our primal desires, it seems that our material culture is more interested in indulging them.

Our relationship with our possessions is never straightforward. It is a complex blend of the knowing and the innocent. Objects are far from being as innocent as Berger suggested, and that is what makes them too interesting to ignore.

1 | LANGUAGE

TO START WITH THE OBJECT THAT IS CLOSEST to hand, the laptop with which I wrote these words was bought at an airport branch of Dixons. There is no one or nothing else but me to blame for my choice. Not even what Berger called publicity. Some shops are designed to seduce their customers. Others leave them to make up their own minds.

Dior and Prada hire Pritzker Prize winning architects to build stores on the scale of grand opera to reduce shoppers to an ecstatic consumerist trance. Not Dixons. A generic discount electronics store at Heathrow is no place for the seductions, veiled or unveiled, of the more elaborate forms of retailing. Nor can I ever remember Dixons advertising itself to try to persuade me to enter its doors, even if the companies whose products it sells do. In an airport,

there isn't the space or the time to be charmed or hypnotized, for nuances or irony. Transactions here are of the most brutal kind. There are no window displays. No respectful men in Nehru jackets and electronic ear prosthetics open doors for you. There are no layers of tissue paper wrapping for your purchases, or crisp, unused new banknotes for your change. There is just the inescapable din of a mountain of objects piled high and sold not that cheaply to divert you.

As the waves of economy-class passengers ebb and flow on their way to the 7 a.m. departure for Düsseldorf, a few will browse among the digital cameras and the cellphones, and a few more will pick up a voltage adaptor. Every so often one of them will produce a credit card and buy something, knuckles white as they key in their PIN code for fear they will miss their flight. Consumption here is, on the face of it, the most basic of transactions, shorn of ceremony and elaboration, reduced to its raw essentials. Yet, even in an airport, buying is no simple, rational decision. Like an actor performing without make up, stripped of proscenium arch and footlights, the laptop that eventually persuaded me that I had to have it did it all by itself.

It was a purchase based on a set of seductions and manipulations that was taking place entirely in my head, rather than in physical space. And to understand how the laptop succeeded in making me want it enough to pay to take it away is to understand something about myself, and maybe also a little about the part that design has to play in the modern world. What I certainly did not have uppermost in my mind was that it would be the fifth such machine that I had owned in eight years.

By the time I reached the counter, even if I didn't know it, I had already consigned my old computer to the electronics street market in Lagos where redundant hard drives go for organ harvesting. Yet my dead laptop was no time expired piece of transistorized, Neolithic technology. In its prime, in the early weeks of 2004, it had presented itself as the most desirable, and most knowing piece of technology that

I could ever have wanted. It was a computer that had been reduced to the aesthetic essentials. Just large enough to have a full-size keyboard, it had a distinctive, sparely elegant ratio of width to depth. The shell and the keys were all white. The catch holding down the lid blinked occasionally to show that it guarded a formidable electronic brain even when you weren't directly engaged with it. Turn the machine over and you could spot lime-green flashes of light tracking across its belly, telling you exactly how much power the lithium battery had left. This was just another decorative flourish with a utilitarian alibi, but it tapped directly into the acquisitiveness vein.

Apple's designers were quick to understand the need to make starting a computer for the first time as simple as locating the on switch. They have become equally skilled at visual obsolescence.

When I bought my first laptop, in the Apple store in New York in 2003, I really believed that we were going to grow old together. This was going to be an investment in my future, a possession that was so important to me that it would last a lifetime. I knew perfectly well that it was an object manufactured in tens of thousands. Yet somehow it also seemed to be as personal and engaging an acquisition as commissioning a bespoke suit. It turned out to be just one episode in Apple's transition from scientific equipment to consumer not-very-durables.

Apple takes the view that its route to survival in a world dominated by Bill Gates's software, and Chinese hardware, is to use design as a lure to turn its products into aspirational alternatives to what its competitors are selling. It expects to sell fewer machines, but it charges more for them. That involves serial seduction. The company has to make most of its customers so hungry for a new product that they will throw away the last one every two years.

The idea that I could so soon be junking something that had so recently seemed to promise so much would once have been inconceivably profligate. But this was exactly the dream of the American mar-

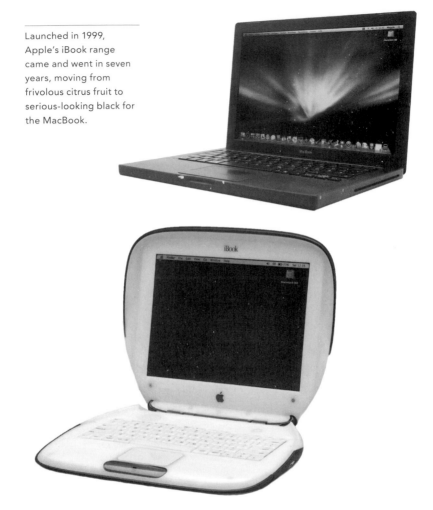

Launched in 1999, Apple's iBook range came and went in seven years, moving from frivolous citrus fruit to serious-looking black for the MacBook.

keting pioneers in the 1930s, who had been determined to persuade the world to consume its way out of the Depression. The advertising pioneer Earnest Elmo Calkins coined the term 'consumer engineering'. He suggested that 'Goods fall into two classes: those which we use, such as motor cars, and safety razors, and those which we use up, such as toothpaste, or soda biscuits. Consumer engineering must see

to it that we use up the kind of goods we now merely use,' he wrote in *Consumer Engineering: A New Technique for Prosperity*, published in 1932. Apple has made it happen, just at the moment that the world is beginning to understand that there are limits to its natural resources. It has given the relentless cycle of consumption a fashionable gloss, cynically endorsed by hipsters in black jeans and black T-shirts, rather than corporate suits.

The immediate predecessor of the all-white Apple that I used to own was a semi-transparent, citrus-tinted jelly mould that established Jonathan Ive's name as the Harley Earl of the information age. Earl was the Detroit car designer responsible for elevating tail fins in the 1950s higher and higher every season. He was the creative master of chrome. Ive, the British-born designer who has become as much a part of the Apple identity as Steve Jobs, has done the same with polycarbonate.

My new laptop was an impulse buy, but not that much of one. I knew that I wanted, though I can't really say needed, a new machine, because the white one, just two years old, had already lost the use of its screen once. Fixing it took an astounding six weeks while Apple sent it to Amsterdam for a new motherboard. If the same thing had happened again it would have cost 60 per cent of the price of buying a new machine, and what came back would have been notably under-equipped in comparison with the latest model in the Apple catalogue. I could also still remember that I had been forced to replace two successive keyboards because the letters had rubbed away within weeks, leaving the machine even more minimal than I had bargained for. And so I was in a frame of mind to open my wallet.

At Heathrow, there were two Apple models to choose from. The first was all white, like my last one. The other was the matt black option. Even though its slightly higher specification made it more expensive, I knew as soon as I saw it that I would end up buying it. The black version looked sleek, technocratic and composed. The

purist white one had seemed equally alluring when I bought it, but the black MacBook now seemed so quiet, so dignified and chaste by comparison. The keys are squares with tightly radiused corners, sunk into a tray delicately eroded from the rest of the machine. The effect is of a skilfully carved block of solid, strangely warm, black marble, rather than a lid on top of a box of electronic components.

Black has been used over the years by many other design-conscious manufacturers to suggest seriousness, but it was a new colour for Apple. It is no coincidence that black is the colour of weapons: the embodiment of design shorn of the sell factor. Black is the non-colour, used for scientific instruments that rely on precision rather than fashion to appeal to customers. To have no colour implies that you are doing would-be purchasers the honour of taking them seriously enough not to try fobbing them off with tinsel. Of course this is precisely the most effective kind of seduction. And in the end black too becomes an empty signal, a sign devoid of substance.

No sooner had my new laptop come out of the box than it was clear that, while Apple's design team, credited on the back of the instruction manual for creating this prodigy, had been clever, they had not been clever enough. They had managed the impressive trick of concealing a preloaded digital camera in the screen. It's an arrangement that offers the memorable conjuring trick, as you go through the online registration process, of suddenly presenting you with your own image blinking back. But the design team at Cupertino had not addressed the technically less demanding issue of the power cables with the same concentration.

While the machine is black, the cables are white. And so is the transformer, a visually intrusive rectangular box. As is the equally intrusive power plug. There is nothing about this lack of colour coordination that makes the computer work any less fluently, and yet I could feel my sense of disappointment rising as I unwrapped my pur-

chase. How could this portal to the future have such shaky, inconsistent foundations? It felt like discovering Al Gore at the wheel of a Hummer.

What is it about consistency that seems to bestow the authority of logic, rigour and calculation? The origins of the aesthetic vocabulary of the MacBook come at just a few steps removed from the spirit of the Bauhaus that sanctified the geometry of the cube, the sphere and the cone. For the latest generation of its products Apple has borrowed a formal uniform that suggests modernism, integrity and high-minded seriousness (as opposed to the playfulness of all that citrus-fruit-coloured plastic it used to sell). Yet an essential part of that uniform is consistency. Apple couldn't manage to do something as obvious as match the laptop and the cables, casting doubt on the integrity of the whole conception. A tree has consistency: the outline of its silhouette, the shape of a leaf, the rings on its trunk, the shape of its roots are all formed by the same DNA, and they are all of a piece. And at some level we look for man-made objects to reflect, or mimic, this quality. When they are revealed not to have it, we are disappointed.

Disappointing in a different way is Apple's introduction of a magnetic latch connecting the machine to its power cable. It certainly stops you from inadvertently bringing the machine crashing to the floor. If you trip over the cable, it comes away with no more than the lightest pressure. But it also means that the power cord and transformer from the previous model, – accessories that had cost a far from negligible £100 as a separately purchased item when I left the first ones behind in a Venetian hotel room – are now utterly redundant.

Even worse, I already knew what the impact of my actually possessing this highly desirable, and desired, object would have on that svelte surface. The very first time it came out of its foamed plastic wrapping, my fingerprints would start to burn indelible marks into its infinitely vulnerable finishes. The trackpad would start to fill up

with a film of grease that, as time went on, would take on the quality of a miniature duck pond. Electrostatic build-up would coat the screen with hair and dandruff. The designers, so ingenious and skilful in so many ways, were evidently still unwilling to acknowledge the imperfections of the human body when it comes into contact with the digital world. However, for true believers, there is a way to protect a MacBook. You can buy a film to wrap the machine in a whole body condom to insulate it from all human contact.

Laptops are by no means the only consumer objects to be betrayed by their owners. Simply by using them, we can destroy almost all the things that we persuaded ourselves to love. When it was new, the metal coated plastic body of my mobile phone from Nokia served to suggest that it was the last word in technology. Within a few months, under the constant pressure of my restless fingers, it turned into an unsightly lump of dumb polycarbonate, apparently scarred by the most scabrous of skin diseases as the metallic finish flaked away to reveal grey plastic under the polished surface. And, while its physical shape suggested a genuine attempt to create an object with which you might want to share your waking hours, other aspects of its performance are less engaging. The way that you have to negotiate the sequence of screen based transactions and controls to operate its camera, or reach the Internet, is as awkward as attempting to use its keypad while wearing welder's gloves.

The idea that our possessions reflect the passing of time is hardly a new concept. The traces of life as it is lived once seemed to add authority to an object, like those battered old black Nikons that Vietnam-era war photographers lugged around the killing fields of South East Asia, the shiny logo taped over to avoid the attention of snipers, the heavy brass body showing through the chipped black paint. These were objects to be treated with a certain respect. They were the product of craftsmen, ingenious mechanical contrivances that, at the press of a

button, would lift the mirror that allowed you to see through the lens. These were objects with the sheer physical presence to reflect their intelligence and their value. They would last and last, delivering the performance promised by the skill with which opticians had ground their lenses, and the care with which the metallic blades that defined their shutter apertures had been designed. These are not qualities that diminish with the years.

Possessions that stayed with us for decades could be understood as mirroring our own experiences of time passing. Now our relationship with new possessions seems so much emptier. The allure of the product is created and sold on the basis of a look that does not survive physical contact. The bloom of attraction wilts so rapidly that passion is spent almost as soon as the sale is consummated. Desire fades long before an object grows old. Product design has come to resemble a form of plastic surgery, something like a Botox injection to the forehead, suppressing frown lines to create a brief illusion of beauty. It's only the SIM cards embedded in our phones that have the ability to learn from us, to mark our friendships and our routines through the numbers that we record on them and to make meaningful patterns out of them.

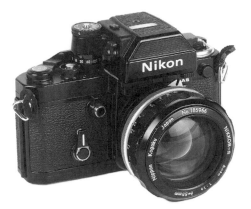

Nikon started making its F series single-lens reflex cameras in 1959. The black body signalled that it was aimed at professionals.

But these, like our Google records, can be the source of well-justified paranoia as much as of comfort.

There is an effective, emotionally manipulative advertising campaign for one particular Swiss watch company whose pitch is that you never actually own one of its products: you just look after it for the next generation. It is an insight into the class-consciousness that is another way to understand the language of objects. Alan Clark's diaries record an acid description of his fellow Conservative minister Michael Heseltine as looking like the kind of man who had to buy his own furniture. The suggestion was that it was only the vulgar, or the socially unfortunate, who would wish to do anything so crass as to buy a new dining table rather than inherit one. (Curiously, it was Clark's father, the art historian and former director of the National Gallery Kenneth Clark, who was responsible for *Civilisation*, the television series and accompanying book that provoked John Berger to riposte with *Ways of Seeing*.)

While the watch campaign does successfully suggest a certain aura around a product, it does not challenge the essentially fleeting and ever more transient nature of our relationship with our possessions. Until the end of the 1980s, a camera was designed to last a lifetime. A telephone was leased from the government, and built to withstand industrial use. A typewriter was once something that would keep a writer company for an entire career. I still have my father's portable. Its laminated-cardboard base has come unglued, spilling out from under its black-fabric-covered plywood box. Its keys have rusted together, the bell is stuck, and the tattered ribbon is worn through with multiple imprints from the lower-case *e*. From a practical point of view it is entirely useless. But I still can't bear to throw it out, even though I know that someday whoever clears out my own house will face the same dilemma that I did. To discard even a useless object that I don't look at from one year to the next is somehow to discard part of a life. But to keep it unused is to experience silent reproach every time

you open the cupboard door. The same reproach is projected by a wall full of unread books. And once read they ask quietly at first, but then more and more insistently, will we ever read them again?

So many product categories have not just been transformed, they have been entirely eliminated. We have lived through a period that, like the great dinosaur extinctions, has wiped out the beasts that roamed the landscape of the first industrial age. And, in the wake of the extinctions, the evolutionary process has accelerated wildly out of control. Those industrial objects that have survived have a life cycle measured in months, rather than decades. Each new generation is superseded so fast that there is never time to develop a relationship between owner and object.

Just a few of these useless objects re-enter the economic cycle as part of the curious ecology of collecting. But collecting is in itself a very special kind of fetish, perhaps one that is best understood as an attempt to roll back the passing of time. It might also be an attempt to defy the threat of mortality. To collect a sequence of objects is, for a moment at least, to have imposed some sense of order on a universe that doesn't have any.

Objects are the way in which we measure out the passing of our lives. They are what we use to define ourselves, to signal who we are, and who we are not. Sometimes it is jewellery that takes on this role, at other times it is the furniture that we use in our homes, or the personal possessions that we carry with us, or the clothes that we wear.

And design has become the language with which to shape those objects and to tailor the messages that they carry. The role of the most sophisticated designers today is as much to be storytellers, to make design that speaks in such a way as to convey these messages, as it is to resolve formal and functional problems. They manipulate this language more or less skilfully, or engagingly, to convey the kind of story that my MacBook whispered in my ear at Heathrow.

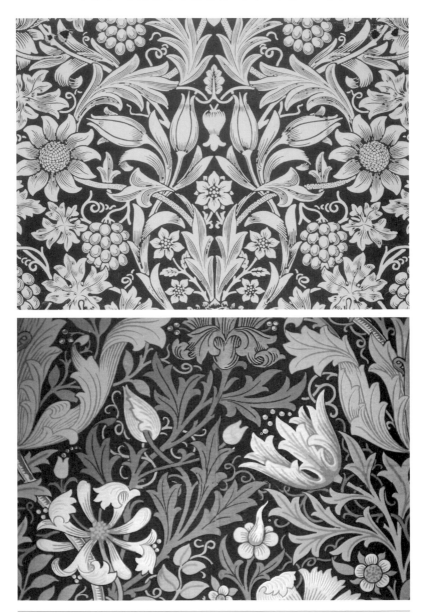

William Morris rejected industrial production and tried to give design a moral dimension by looking back to the Middle Ages for the ornamental patterns derived from nature in his work.

To understand the language of design, we also need to understand how the designer has evolved as a professional. Ever since design emerged as a distinct activity, closely linked to the development of the industrial system towards the end of the eighteenth century, designers have lurched from seeing themselves as social reformers, idealists, profoundly out of sympathy with their times, like William Morris in nineteenth-century England, to become the charismatic snake-oil salesmen led by Raymond Loewy in mid-twentieth-century America. Morris hated the machine age, and tried to find a way to re-create the tradition of the hand crafted object. Loewy once promised to streamline the sales curve.

For Morris, what he saw as the joy of labour was the key to creating meaningful everyday possessions. He wanted to eliminate the 'lifeless' mechanically applied decoration of the high Victorians, to replace it with simple, direct forms that both harked back to the Middle Ages and set a marker for the future. As a precocious 17-year-old in 1851, he was taken by his mother to see the Great Exhibition, Prince Albert's triumphant celebration of the Industrial Revolution. But so stubbornly convinced was Morris that every manifestation of the machine age was not just aesthetically worthless, but an affront to humanity, that he stayed outside. He refused to enter the Crystal Palace, sure that he would find nothing but meretricious rubbish inside. And in a way he was right: Joseph Paxton's brilliant prefabricated cast-iron and glass structure contained, among many other things, the Venus de Milo carved in butter.

But, despite his progressive social message, Morris later relied on 13-year-old labourers in his carpet factory in Wandsworth. He was not just a revolutionary socialist, he was also a wallpaper designer – a combination that might have been the invention of a satirist. And he found that his decorating business depended on what he himself described as pandering to the swinish luxury of the rich. Morris

became a libertarian socialist, a pioneer in the struggle for the emancipation of women and in the movement against colonialism, even as he lived on the income of the mining shares left him by his father.

As an alternative to the view of the world represented by the Crystal Palace, Morris offered a romantic retreat into pre-Raphaelite nostalgia. He loved old buildings, the countryside, Icelandic sagas and traditional ways; he loathed machines, railways, big cities and suburbs. His vision has exercised a powerful influence on the English imagination ever since. Morris's rural dream has an uncomfortable echo in the tendency of the newly rich to retreat from the city in which they made their money to Wiltshire manor houses, and to react with moral outrage to attempts to build housing estates anywhere near them.

Morris designed beautiful textile and wallpaper patterns that many people still love to use. Raymond Loewy, by contrast, just wanted to help Lucky Strike sell more cigarettes by changing the colour of the packs they came in. Despite his overheated claims to have designed *Air Force One* for Jack Kennedy, the Coke bottle and NASA's spacecraft, he started his career in New York after the First World War, a penniless French engineering graduate fresh off the boat, working as a fashion illustrator and window dresser.

Loewy offered a slicker and smoother version of what design could be. He turned cleaners, duplicating machines and pencil sharpeners into glossy fetish objects, used as props to define the modern workplace. He designed some of the most spectacularly beautiful products of his time – in particular his cholesterol-rich streamlined steam locomotives that marked the end of the railway age. But he also constructed an idealized version of his office in the Metropolitan Museum in New York, and hired a publicist to help him get on the cover of the *Time* magazine. He was a brilliant striker of attitudes for the camera, perched on the footplate of one of 'his' locomotives.

Raymond Loewy was perhaps his own greatest creation: the very image of the new breed of designer, in business to streamline the sales curve for anything from locomotives to cigarettes.

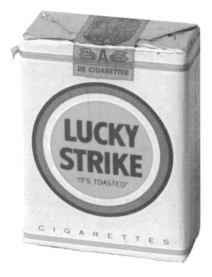

Somewhere between these two versions of design is the idea that design is a public service. It's notable that in Britain one of the first industrial-design practices that emerged in the 1940s called itself the Design Research Unit, a name calculated to suggest that it was a branch of the Welfare State more than any kind of commercial activity, even though it was actually started as the subsidiary of an advertising agency.

Not long before that, wartime Utility furniture ranges designed to government specifications had offered newly married couples and bombed-out families beds and sofas and tables that were a model of rational intelligence. They were also very probably responsible for turning a generation of British consumers against the whole idea of modern design, a phenomenon that had come to be inextricably associated in many peoples' minds with shortages, deprivation and the condescending imposition of good taste by the privileged elite on their social inferiors.

Following in Loewy's footsteps today is Philippe Starck. Nobody

better encapsulates the contemporary version of the designer as celebrity, capable of transforming anonymous domestic objects with his signature.

For about five minutes in 1984, the most fashionable bar on the most fashionable street in Paris was called the Café Costes. This was in the days when Spandau Ballet were regarded as a serious musical force and turning back the cuffs of your jacket was seen as making a worthwhile fashion statement. It was not the food or the wine list that packed them in at the Café Costes. It was the chance to spend half an hour sitting on a three-legged chair in Starck's very first interior, waiting for a coffee that never came.

Starck called the look of Café Costes 'Budapest railway station third-class waiting-room circa 1956'. There was a plunging staircase, a gigantic clock filling most of one wall, and that chair. It had a semi-art-deco, faux mahogany plywood shell, held up on three black steel legs 'to help the waiters, because it gives them less to trip over', as Starck put it. Before you could check whether what he said was true, however, Café Costes had faded into an oblivion even sadder than the melancholy of central Europe under Stalin. The fashionable moved on, leaving the chairs to backpackers, and the café soon closed. But it was Café Costes that triggered off the plague of designer kettles, hotels, mineral water, pasta, toothbrushes and all the other useless paraphernalia that now laps around the world, confined for the most part to forgotten drawers and dusty kitchen shelves.

Amazingly, Starck, once the most overexposed designer in the world, who has built a career as much on his own force of personality as on the objects he designs, has not changed. He is still working to the same formula, based on a well-worked decorative palette, surrealistic jumps of scale, cute anthropomorphic styling, and a cloying habit of trying to attach absurdly unpronounceable names to everyday objects. Inviting us to walk into Dixons to ask for a transistor radio named

[28]

Moa Moa, as he did, is cruelty on a level with Frank Zappa's when he named his daughter Moon Unit. But, at fifty-something, Starck still has the persona of a small boy, constantly seeking to amuse the grown-ups with his daringly naughty tricks, and still looking over his shoulder for their approval.

And they do approve. The Pompidou Centre, just around the corner from the long-gone Café Costes, staged a Starck retrospective in 2002. The show had all the egotism of mid-period Michael Jackson, when the singer took to floating giant effigies of himself down the major rivers of Europe. Inside a darkened circus tent, Starck positioned a ring of neoclassical laurel-wreathed heads standing on fibreglass plinths 10 feet high, mocked up to look like marble. The heads all had the alarmingly lifelike features of Starck himself, and harangued the darkened room in a simultaneous babble. If that wasn't incoherent enough, the random sound effects, the snatches of music, and Starck himself bursting into song or dissolving into incoherent yelps as if he were speaking in tongues at a revivalist prayer meeting put the experience beyond the threshold of pain. Groups of spectators pulled up chairs and strained to make sense of the snatches of wisdom from the master's lips, moving from one

As much a storyteller as anything else, Starck's way with words got him noticed, along with his enthusiasm for three-legged chairs. His moulded chipboard TV for Thomson brilliantly disrupted the conventional language of consumer electronics.

graven image to another. It was disturbingly like sitting in on a group-therapy session.

Starck certainly has a way with words. 'Ian Schrager asked me to design a $100-a-night hotel room in New York. I was totally into it. For $100 a night in New York, you usually have to sleep with rats.' And anybody who can design the men's room in the top-floor restaurant of the Peninsula Hotel in Hong Kong with a glass urinal looking out over the lights of Kowloon is clearly prepared to bite the hand that feeds him enough to be entertaining. You could forgive him his boundless egotism if it wasn't for the fact that he opened the doors for a generation under the impression that all it takes to be a design genius is an ego and an inability to stop talking. You could even forgive him the cracker-barrel philosophizing if he didn't still present himself as a breathless iconoclast storming the gates of convention everywhere he goes to liberate us all.

Starck may be under the impression that he is telling us everything about his dreams and our innermost desires in his objects. But he doesn't tell us that. Try as he might, even his brilliantly conceived retro TV sets, radios and CD players could not improve the fortunes of Thomson, the French state-owned consumer electronics company, which made them. Ultimately Starck has only one trick, and it's a good one: his childlike view of the world. His motorcycle for Aprilla might have looked cute (in his words, 'It has the red ears and dripping nose of a real animal'), but it didn't sell.

The Thomson set that he chose to name Jim Nature showed his real genius in its ability to play with the conventions of product design and the signs that it uses to signal status and price. Instead of encasing the TV in moulded plastic, of more or less sleekness, Starck went back to wood. In the early days of television, the set that occupied the corner of a room, sitting on top of its own stand, perhaps covered with a linen cloth when not in use, would have been finished in a lacquered

veneer. Starck used chipboard. It was an extraordinary deconstruction of the language of materials, and the signals of luxury.

There is another view of design, the polar opposite to that represented by Starck. It is the idea that design is concerned with the pursuit of some sort of inner truth and meaning, a view most recently characterized in the person of Dieter Rams. As was William Morris, Rams is driven by a sense of the moral purpose of design, though he does not share Morris's antipathy towards the machine age.

Rams devoted enormous effort and patience to designing perfect objects that could defeat fashion and overcome the passing of time by defying visual redundancy. He dreamed of objects that became timeless by eliminating the superfluous, reflecting intellectual rigour rather than trying too hard to please. Rams made the perfect calculator, with the most carefully considered radiused corners, and the neatest buttons, and the clearest sequence of operating functions. But, with almost unbearable pathos, his most cerebral and high-minded attempt to put design beyond fashion and time ended in the creation of objects with a life expectancy no longer than one of Raymond Loewy's streamlined steam locomotives. The radio and calculators and record players have each of them been supplanted, not just by newer, younger models, but by entirely new categories of object.

And, in the end, even such an apparently intellectually rigorous designer as Rams is still concerned with what might to an engineer be characterized as superficial styling. Just how innovative is the technology needed to produce an electric shaver after all? Did Rams have a genuine grasp of the developments in recording technology that he housed in Snow White's coffin, the first Perspex topped domestic record player, which defined the type for two decades? Probably not. But then the physicists and programmers and engineers who between them made the iPod and the MacBook possible for Apple would never have managed to produce a commercially seductive product without

Jonathan Ive. And Ive would never have made the MacBook the way it is if Rams had not existed. What Rams did with the Perspex top was to define how audio systems would look right up until the moment when the record was supplanted by the compact disc.

In the end, design cannot be understood by looking only at the world represented by Rams, just as it is not adequately encompassed by the perspective of a Raymond Loewy. Design is about the creation of anonymous mass-produced objects, by people who spend a lot of time worrying about injection moulding, or about the precise degree of curve needed to blunt the sharp edges of a monitor screen. It is also about making objects that feel good to touch and to use.

However, the old definitions of design, and the skills that realizing them demanded, are being marginalized by the rapidly changing nature of objects. The most noticeable change is the way that so many artefacts are converging. There was once a separate category of object known as a telephone, which existed alongside another, entirely separate, category called the camera. And the printer was not the same as the copier or the fax machine. Now a phone and camera, with an MP3 player, a radio and an email communicator, are all subsumed into a single object, as are the printer, the copier and the fax machine.

At the same time, the decline of low-cost manufacturing in the West has transformed the nature of the design process. Ask an industrial designer to 'design' a new bike, or a watch, and it will very likely involve a trip to China to select from a hundred different alternatives off the shelf for most of the components, then assembling them in such a way as to give the result a distinct personality. In this context, design is more important than ever, but it is not only about engineering. Or the design of original components.

The argument about the nature of design should not be polarized between style and substance. The surface of things matters, but we also need to be able to understand what lies beneath. Design is

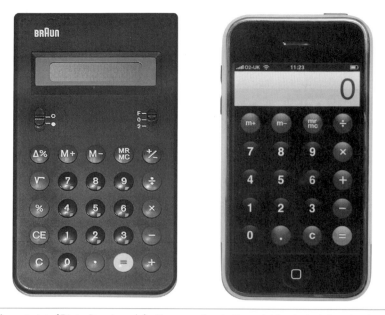

The restraint of Dieter Rams's work for Braun was the starting point for the look Jonathan Ive gave Apple products. But while Rams wanted to design objects that would last for ever, the original iPhone was superceded in six months and the calculator interface lost its Braun look.

no longer based on mechanical models. The typewriter had moving parts that the industrial designer could conceivably impact upon. How many moving parts are there for Jonathan Ive to manipulate? How much is a working knowledge of the laws of thermodynamics going to help in designing a modern consumer electronics product? What the designer is left to deal with is the surface, the appearance, and semantic shades of meaning that allow us to interpret and understand what an object is trying to tell us about itself. These messages range from what an object does, to how much it is worth, to how to switch it on. They are far from trivial issues, but they turn the designer into a storyteller. And, while it is certainly true that design is a language, it is only those who have a convincing story to tell who know how to use that language fluently and effectively.

Contemporary designers in the end must deal with multiple definitions of their purpose. A pair of glasses is both a medical appliance and a fashion accessory. The long associations of spectacles with bookishness are presumably what serve to signify the connotations of maturity that they can confer on their wearers. Glasses are jewellery of a kind: they modify appearance, and so personality. But at the same time we don't want them to break too easily, or to strain our eyes.

In understanding the language of design, expressed by the shape, colour, texture and imagery of an object, there are constant paradoxes between function and symbolism to be addressed. Certain colours are associated with the male more than the female. Some materials suggest luxury.

The question that is worth asking is, are these actually inherent qualities, or are their meanings acquired through constant repetition, through familiarity and convention, just as road signs still use the pictogram of a steam engine to suggest a level crossing half a century after such machines fell out of common use.

Ernesto Nathan Rogers was an Italian architect, a cousin of Britain's Richard Rogers, and responsible for Milan's most distinctive tower of the 1960s, the Torre Velesca. He suggested in an editorial that he wrote for *Domus* magazine in 1952 that it is possible, from a careful examination of a spoon to understand the kind of city that the society that had produced it would build. Of course he was exaggerating for effect. To judge London on the basis of what you find by shredding the cellophane wrapper on the plastic spoon that comes with the British Airways All Day Deli offering on the flight from Milan to Heathrow would give you a fairly distorted idea about the place. Yet there is still something curiously compelling about his words.

Rogers was talking about the way that Italian architects were able to switch effortlessly from cutlery to skyscrapers without missing a beat. And that is a phenomenon that you see even more of these days,

though now it perhaps has more to do with branding – the designer's signature has come to mean as much as anything more directly useful that they can bring to the project. The extent to which once anonymous, humble but useful designs have been turned into objects that demand to be noticed on the basis of the designer's signature can be measured by the frequency with which Alessi, or even more strikingly America's mass-market retailer Target, put postmodern architect Michael Graves's picture on the box in which his designs are packaged.

Without actually using the word, Rogers was making a powerful argument for the significance of design in the contemporary world. The spoon could be understood as a fragment of genetic code – a code that can grow into any kind of man-made artefact. Traces of the same code can be found in anything that shares the same design roots – a chair, a car, a typeface, even an aircraft, never mind a skyscraper or a city.

The code is partly a reflection of how the object is made, but also of its symbolic meaning.

The issue here is not so much of consistency in the sense of using the same elements, shapes and colours over and over again. What counts is the nature of the thinking, and the methods that are used.

If you question the premise that objects mean anything beyond the utilitarian, just think for a moment about all the emotional content so far beyond legibility that we can read into the minute nuances that shape a typeface and give it a personality. The fact that it's called a 'face' at all is certainly not a coincidence. Type is fully capable of showing the character and personality of the human face.

Examine a spoon carefully and you can understand enough about the society that made it to visualize how they would design a city, claimed Ernesto Rogers.

Compare for a moment the message that using Helvetica rather than Gothic for a newspaper headline conveys, and the subtle variations between these two extremes. In the shape and form of a letter we have all the characteristics of an accent. Literally so. I can hear Switzerland when I look at Helvetica. And when the Basque nationalist movement began to establish itself, at the end of the nineteenth century, one of its founders made obsessive transcriptions of the ancient carvings on stones throughout the country to come up with a specifically Basque typography. Partly through association and memory, partly through the emotional triggers and resonances it brings, a typeface expresses an endless range of characteristics, even wider in its scope than handwriting. But, while it takes a graphologist to decode individual signatures, typographic design can communicate on a conscious or unconscious level with everybody, whether aware of the vocabulary of type or not. Send an email in capital letters, and you know that you have raised your voice to a shout. Remember the graphic designer Otl Aicher's belief that if only Germany had not

Max Miedinger and Eduard Hoffmann designed Helvetica in 1957 as the personification of Swiss discipline.

been so fond of capital letters it would have been less vulnerable to the rise of fascism.

Print is self-evidently a means for communicating. Perhaps not quite so self-evidently, the communication is not simply in the formal meanings of the words spelled out by letter forms. How those letters are themselves organized and shaped and designed has come to offer another level of information. The shapes of letters convey levels of meaning that go beyond the literal content of the words themselves. This is sometimes discussed in terms of legibility, as if the only purpose of typography were to make it possible to read a word in any lighting conditions, without any kind of ambiguity. The US highway signage system can be explained in these terms. The upper-and-lower-case rendering of place names in the bold and unambiguous forms of Interstate, as the vernacular signage alphabet in the USA is known, has certain practical tasks to achieve. You need to know in the rain and at 70 miles per hour which turning to take to find your destination. But Interstate is also telling you a whole range of other things. When you see it, you know, without actually needing to read any words, that you are on a freeway. You know that you are in America rather than Britain.

It's a language that you understand even when it is used for completely different purposes and contexts. A form of Interstate has started to appear in British newspaper headlines, to suggest the dynamic and the contemporary. It's a graphic device that represents a process comparable with the literary transformation of heroic verse forms to satirical purposes. Or even to the way in which neo-Palladian architects adapted the architectural language of the Veneto to the Anglo-Saxon world, just as Palladio himself had borrowed the forms of ancient Rome. To shrink a font designed for use on signs spanning an eight-lane highway to the size of a tabloid newspaper has the impact of an explosion in a tiny room. Or at least it does the first few times that it

Designed to be legible in all weathers and at high speeds on American freeways,
Interstate is a typeface that transcends function.

is done. After a while the impact wears off. We get used to being daz-
zled, and our senses recalibrate to adjust to the volume.

And if graphic design can be a language, then so can other forms
of shape making, or form giving. When the great French engineer
Pierre Boulanger worked on the Citroën 2CV just before the Second
World War, he was not consciously trying to make a car that looked
French, though that is what it clearly became – and not just because
there were so many 2CVs on the roads of France. The 2CV was
designed with the special peculiarities of the French market in mind.
It was designed to sell at a price within the reach of French farmers,
and built to be robust enough to survive on France's rural roads in the
1930s. The result was a car whose style reflected those requirements.

And it was built with metal forming techniques that reflected the ideas of Jean Prouvé, the quintessentially French engineer architect. Put a 2CV alongside a Volkswagen, designed by Ferdinand Alexander Porsche – with some unwilling help from a Czech engineer, Hans Ledwinka – to show Teutonic industrial prowess in its best light and to populate Hitler's autobahns, and you knew immediately which was German and which was French.

Pierre Boulanger devised the Citroën 2CV as an affordable workhorse, robust enough for French roads. Early versions came with a single headlamp in the interests of economy.

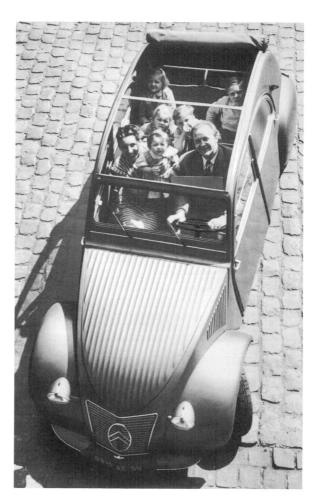

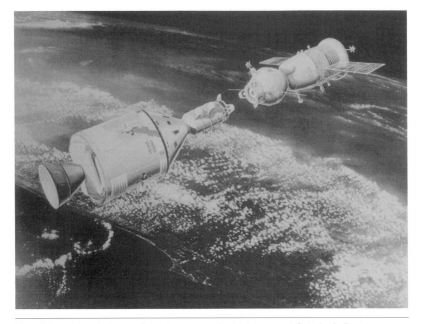

Two objects intended to perform the same tasks, in the same, infinitely challenging conditions, but the Soviet Soyuz and American Apollo space capsules look utterly different, betraying the visual assumptions of their makers.

In the same way you might look at the Soviet and American space capsules that docked in Earth orbit, and which now hang in the Smithsonian Museum in Washington, and see two different national mentalities rendered in physical form. They are two objects designed to do exactly the same thing, in the most extreme of conditions. And yet they look utterly different, and reflect with shattering clarity two utterly different political and economic systems. One looks as sleek as a Harley Earl limousine, the other seems to belong to the world of Jules Verne, of brass portholes and mahogany fittings.

Things have become more self-conscious and knowing since the apparently innocent early days of car design. Patrick LeQuement, working for Renault in the 1980s with a brief to make a car that looked

as cute as the family pet, produced the Twingo. He addressed the task by introducing the most obvious of anthropomorphic characteristics: headlamps that look like eyes, and a winning smile for a radiator grille. Indeed, car design in the era of the brand has come closer to a species of selective breeding, like raising sheep and cattle. There was a time when a car designer operated on the basis that nobody had ever designed a car before. Now the designer's greatest challenge is to ensure that a new Jaguar, or Mini, or Golf, shows all the right family traits, from the wheel arches to the door handles, just as a breeder of pedigree dogs concentrates on giving dachshunds long bodies and short legs.

When looking back at the history of the twentieth century, it is hardly controversial to suggest that the most significant piece of car design was the launch, in 1908, of the Model T Ford, which remained in production for the next two decades. But it's probable that in some ways the Nissan Figaro, first shown at the Tokyo Motor Show in 1989, and of which only 20,000 were ever made, was equally significant – not for mechanical or technical reasons, but because for the first time in the history of automotive design the car was being treated not as a serious piece of technology, but as a toy. And once the genie was out of the bottle it was too late to put it back.

The Figaro made us see cars differently. It was carefully designed to suggest that it belonged to a period sometime between the late 1950s and the early 1960s – its white plastic steering wheel, its dumpy curves, its muddy plastic colours reflected a stitching together of the advertising and cinema images of the period. But the technology under the bodywork was from Nissan's most modern production lines. This kind of approach reflects the way a fashion collection is put together, starting with a mood board rather than a technical problem. The question becomes how to blend 1940s film noir with punk on a military-style jacket, rather than how to reduce emissions and locate a spare wheel.

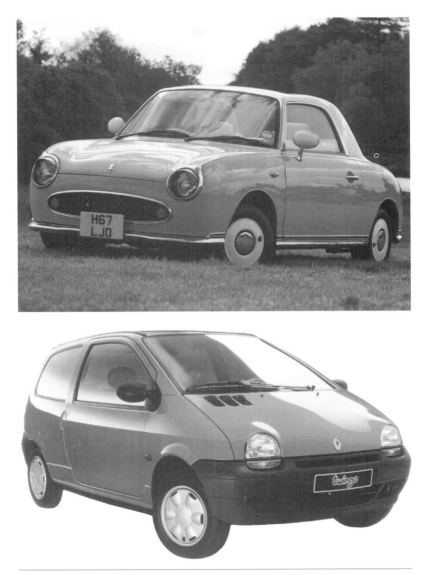

The production line for the Model T Ford started up in 1908. The first mass-produced car was certainly an enormously important design. The Nissan Figaro, eighty years later, can be seen as equally significant, even if it was made in tiny numbers (a limited edition of 20,000) and offered nothing technically new. What made the Figaro a landmark was that for the first time a car was self-consciously treated as a toy rather than as a functional object. Renault quickly followed, giving the Twingo its cute, anthropomorphic look.

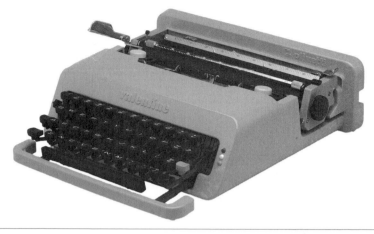

Ettore Sottsass and Perry King transformed the identity of the typewriter from serious, business-like office equipment into a desirable consumer artefact, a trick that Jonathan Ive was to repeat for Apple.

This was not the way that cars had been treated previously. It's true that Harley Earl had also been playing up the emotional aspects of car design, but in his day the inspirations came from contemporary aircraft, and so appeared to suggest that he was still engaged with the real world, rather than with play. And in the early days cars were much less self-consciously referring to precedent, and much more designed from first principles. The Figaro, on the other hand, was the physical realization of the dream that the advertising image of a car could once have evoked, but never have delivered.

Olivetti made the conceptual leap from manufacturers of business equipment to manufacturer of consumer products when Ettore Sottsass first put a handle on a mainframe computer, making it into an object rather than an accumulation of transistors and valves. In the same way, with design, he transformed the office typewriter for Olivetti by making a red-and-orange lightweight portable, the Valentine. As Sottsass memorably put it, the Valentine was designed to keep lonely poets company on weekends in the country. He had realized

that technical equipment could be domesticated. A typewriter did not have to be treated as a piece of anonymous machinery, but could be understood as having a character of its own.

Design in all its manifestations is the DNA of an industrial society – or of a post-industrial society, if that's what we now have. It's the code that we need to explore if we are to stand a chance of understanding the nature of the modern world. It's a reflection of our economic systems. And it shows the imprint of the technology we have to work with. It's a kind of language, and it's a reflection of emotional and cultural values.

What makes seeing design in this way really engaging is the sense that there is something to understand about objects beyond the obvious issues of function and purpose. It suggests that there is as much to be gained from exploring what objects mean as from considering what they do and what they look like.

Design is the language that a society uses to create objects that reflect its purposes and its values. It can be used in ways that are manipulative and cynical, or creative and purposeful. Design is the language that helps to define, or perhaps to signal, value. It creates the visual and tactile clues that signal 'precious' or 'cheap' – even if, given the infinite capacity of the human mind for irony, and the permanent quest for novelty, these signals are regularly subverted. In fashion, once a signal becomes too obvious, its meaning is inevitably inverted. Bad equals good. Sought after becomes inescapably ubiquitous. And the other way around. The naive innocence of East German packaging and product design once signalled the enforced deprivation of a brutal political system. Now it has been defanged and resuscitated by nostalgic interior designers.

It is the language of design that serves to suggest an object's gender, often through the most unsubtle of means, through colour, shape, size and visual reference. It is design that reflects a sense of

authenticity, or its manipulative opposite: cynical salesmanship. And it is design that can serve to signal and reinforce the caste marks of a class system.

Design has become the sometimes cynical process of making what were once serious, unself-conscious products – watches, for example, or cameras, or even cars – into toys for adults, pandering to our fantasies about ourselves, ruthlessly tapping into our willingness to pay to be entertained or flattered by our possessions.

And it is design that can serve as the means for creating a sense of identity – civic, collective or personal. It's design that creates national insignia, and corporate brands.

These multiple definitions of design make it an endlessly fascinating, critically important, and always revealing subject.

Of course, it's not only what design means that counts – the 'why', as it were. The 'how' is an equally powerful way of understanding the physical, material world – not least because technologies and techniques keep evolving and expanding. By combining this technological perspective with an appreciation of the cultural context in which design operates, we have a particularly powerful way of looking at and understanding the world.

Design also has another kind of resonance. Let's not forget that good design is also a pleasure in itself. The aesthetic, sculptural quality of a glass or a chair, and the intellectual elegance of a typeface are creative expressions that we can appreciate in themselves. So is the elegance with which a software programme interacts with its users.

Design is used to shape perceptions of how objects are to be understood. Sometimes it's a question of direct communication: to operate a machine, you need to intuitively understand what it is, and how to make it do what you want. The first laptop or single-lens reflex camera or mobile phone required a designer to define what a lap top, camera or phone should be. Everything that followed has been a variation

on that theme. Sometimes the communication is of a more emotional kind. Precious materials suggest that the objects that they are used to make are themselves more important than those that are formed from less valuable materials.

This is a language that evolves and changes its meanings as rapidly as any other. It can be manipulated with subtlety and wit, or with heavy handed obviousness. But it is the key to understanding the man-made world.

2 DESIGN AND ITS ARCHETYPES

I F THERE IS ONE THING OTHER THAN A CHAIR that every designer wants to have put their name to at least once in their career it is an adjustable light. Quite why this particular category of object, rather than, say, cameras, bicycles or websites, should still have such an appeal is hard to know, but it certainly has something to do with the scope offered to a designer.

An adjustable lamp demands a mix of technology and invention. To get it right demonstrates technical accomplishment, but also artistic ambition. It offers so many variables to work with. There is the whole question of the mechanism, and the way it is articulated to make movement possible with just fingertip pressure. Then there is the structure, which holds the light in place, and also the means

by which the power to the light source is controlled. And as critical as all the other elements is the quality of the light, and the way that it is diffused, directed and shaded. This is a question as much of mood as of anything more easily quantifiable.

Equally important, successful lamps stay in production a long time. Mobile phones are superseded every six months. Canon's new-product development cycle for its cameras is less than two years. Few new cars keep their allure for more than five years before they get a major facelift. Even the Volkswagen Beetle's record breaking 64-year production run eventually came to an end, by which time it was man-ufacturing an entirely different car, in which every single component had changed. But chromed tubular steel chairs which were more than a decade old before the Beetle was first thought of are still being mass-produced, and still look as contemporary as ever. And the first adjust-able task light, the Anglepoise, is still in production after 75 years, with the latest version recognizably a close relative of the original.

The history of design, then, is measured out by a disproportionate number of chairs and lamps. Perhaps what gives the task light its spe-cial interest for designers is that it is a chance to modify an archetype, and possibly even to create a new one.

The Anglepoise is an unassumingly modest artefact, but one that nevertheless has a lot to say about design. It's a desk lamp that does a practical job, directing a concentrated pool of bright light on to a selected surface that can be horizontal or vertical. It can make enough out of a 60-watt tungsten bulb to render 10-point italic type legible for those who are on the brink of wearing glasses. But it is also an engag-ing sculptural object, one that has just a little of the kinetic quality of a Calder mobile. The Anglepoise has no one single definitive shape. Its form continually changes when it is in use – a reminder that how we use an object is as much an important aesthetic aspect of a design as how it looks. At the same time, it has the mechanical appeal of an

anonymous piece of practical engineering. The arms, carefully shaped to accommodate the exposed springs, have a legibility that could be understood as a forerunner of the structural frankness of Piano and Rogers's Pompidou Centre.

The Anglepoise is functional, but it also offers the promise of emotional engagement for its users. Its presence on a desk or a drawing board is an unambiguous sign of concentration, and creative effort.

Objects do not exist in a vacuum: they are part of a complex choreography of interactions. The old-style cathode-ray television screen, housed in a wooden box and treated as a piece of furniture, created a social dynamic in the living room of the 1960s that was entirely different from what happened when portable sets were placed on the floor. This was apparently an informal gesture that dethroned the household god of the first age of consumerism. But, in the days before the remote control, it required an act of ritual obeisance when you got down on your knees to change channel. This is different again from the social impact of a flat screen hung on the wall as if it were a picture. These objects in their different ways determine not just how we use a room, but how we use a whole house. They shape the way we relate to each other, the way we eat, the way we sit, and how we look at each other.

To switch on an Anglepoise and to move it into position is, both literally and metaphorically, to suggest that you have started work. It is like opening the shutters of a shop, or raising a curtain in a theatre. All the senses are involved, sound as well as touch. The click of the switch is like putting up a 'Do not disturb' sign.

Beyond that, even though most of the manufacturing processes that it depends on now take place in China, the lamp retains a certain essentially Anglo-Saxon flavour. Wallace and Gromit are recognizably the product of the same frame of mind.

All of which makes a complex, and multilayered range of mean-

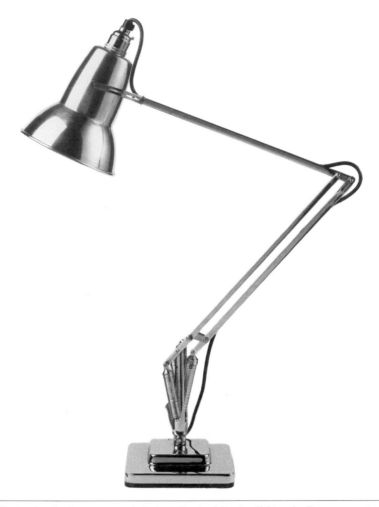

The Anglepoise began as a technical solution to delivering light and selling more springs and became a new word in the language of design.

ings for a relatively simple object to carry. But the Anglepoise is the product of all of them, as its form manages to suggest.

In one way or another, the qualities involved in an Anglepoise can be manipulated by a designer with skill and insight to shape perceptions of almost any object. A refrigerator, a ski boot, a waterproof

jacket, even a whole body scanner or an insulin dispenser are all objects that can be designed in such a way as to suggest a personality, to provide clues as to how to use them, and to make the most of their tactile potential. There are common threads that shape the way that these objects are understood. They all depend on the way that decoration, colour, form, and ritual are manipulated. Even in our post-mechanical era, these elements still have a continuing relevance. How we interact with screens and the digital world is shaped in ways that attempt to evoke the qualities that designers use to manipulate our relationship with the physical world.

The Anglepoise was designed by an automotive engineer named George Carwardine, and, though he predated them, he had the sort of approach that produced the original Mini and the Moulton bicycle. The Anglepoise embodies the same modernizing impulse. Like them, it is an example of a product that has become an archetype. Almost as soon as it was conceived, the Anglepoise turned out to be not just a product, but the first example of what has since become a category, just as the Mini would be 25 years later.

The Mini was the outcome of a remarkable partnership between two gifted and imaginative engineers, Alec Issigonis and Alex Moulton, who transformed the perception of what a mass-market small car could be at the end of the 1950s. Its combination of a relatively spacious interior with compact proportions and high performance was a genuine breakthrough. Two other famous small cars, the Citroën 2CV and the Fiat 500, had both been equally brilliantly innovative designs, but the Mini easily surpassed them in comfort and performance. Issigonis had the critically important idea of saving several inches in the overall length of the car by placing the engine parallel to the car seats, rather than at right angles to them. With the Mini, he invented a new vehicle category, one that other manufacturers in time had no alternative but to follow with their own variations on the basic theme.

The Moulton bicycle—the creation of the same Alex Moulton who had worked on the suspension system for the Mini—was perhaps the biggest shift in two-wheeled-cycle design since the invention of the derailleur gear in 1905, sixty years earlier. Moulton's small-wheeled low-centre-of-gravity bicycles were not perhaps quite as significant a development as the Mini, but they did create a school of eager followers.

The Mini, the Moulton and the Anglepoise were all designs based on a combination of technical innovation and formal invention. All three of them have some of the qualities of the underdog. They were pioneers who lost out to slicker and better organized competitors. But like the iPod, or the first generation of Bakelite rotary-dial telephones, each of them had a form distinctive enough to successfully create a new category of object.

It is not just how an object looks that is the key to the creation of an archetype. A commanding archetype needs a form that can communicate what it does, and what the user needs to do to make it work. If an object comes with an extensive instruction manual, you can be fairly confident that it's never going to be an archetype.

Some archetypes have millennia long histories, with generation after generation producing their own particular interpretations of a given format. These are archetypes that have become so universal as to be invisible, each version building on its predecessors to continually refresh the basic parameters. Who would think of asking who first designed the chair with a leg at each corner?

There are certainly many other archetypes that have endured for centuries: the clock face, the tap and the key, for example. The electric light is a much more recent category. And, despite its comparative youth, the Anglepoise quickly managed to establish itself as part of the essential vocabulary of design.

Before it existed, a lamp that you could move up or down with no

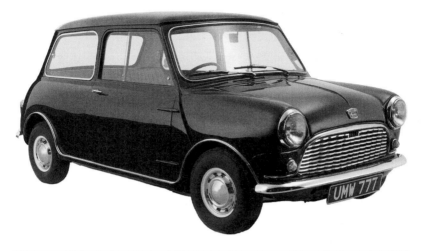

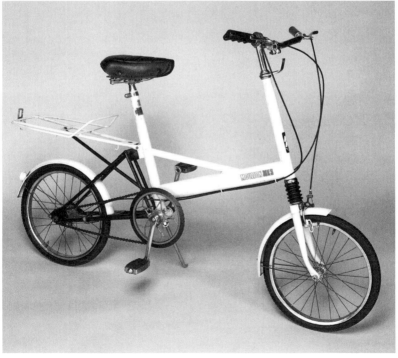

Alec Issigonis's engineering brilliance made the Mini not just a car brand but a category. His collaborator, Alex Moulton, tried to do the same with his bicycle.

more than fingertip pressure from one hand was one of that limitless number of things that we didn't know we couldn't do without. Once it had taken shape, there was a sense of inevitability about the way that the whole combination came together and worked. It was seemingly obvious, but it had never been done before.

The sheer utility of the Anglepoise invited others to improvise their own versions of the basic proposition. It had a visual directness that has enabled it to define a form for a product that countless other manufacturers and designers have followed – not necessarily as direct imitators, though there have been plenty of those, but because they could see the demand for a product capable of doing a similar job in its own way.

The process by which the Anglepoise came into being was accidental, the product not so much of a determination to make a new kind of light as of the search to find new business for an existing production line. A small family owned company, Herbert Terry Ltd, which specialized in manufacturing metal springs, set out to expand their order book. They reasoned that by selling a finished product aimed at the consumer they could find a market for more of their springs. And at the same time they could make more money out of the springs they made by using them as components for their own products, rather than by selling them to other people for use as components in theirs. So Herbert Terry licensed the Anglepoise design from Carwardine, who had been working on the idea of a light that used springs to make it easily adjustable. The original plan had been to call it the Equipoise, but there were problems with copyrighting the name.

Technically, the Anglepoise is all about the springs. They are what allow the lamp to be adjusted with gentle pressure, and then to stay in position. There had been any number of desk lamps before the Anglepoise. Quite a few of them could, with a bit of arm wrestling, have been made to move the light source up or down, or to tip

forward and back. But none of them could do quite what the Anglepoise did, and very few companies could produce springs that had the same tensile characteristics of those that Herbert Terry made. With its unusual mixture of visual frankness and formal delicacy, there was nothing else at the time that looked like the Anglepoise either.

The Anglepoise was a product that grew out of a surprisingly complex set of engineering principles, along with a serious structural analysis, rather than from a purely visual starting point. The springs keep the lamp in equilibrium, without any need for it to be clamped to a bench. The forces involved are balanced out by the springs pulling against each other. How the lamp looks – in particular the form of its shade – was something of an afterthought. But that was part of its appeal. Its artless shape gave it a certain naive innocence that suggested authenticity, just as that the early versions of the Land Rover had the kind of credibility that comes with a design based on a technically ingenious idea rather than the desire to create a seductive consumer product.

In the early days, there was no more than the most sketchy of attempts to refine the raw structural diagram of the Anglepoise. When Carwardine patented the design he made very little out of the aesthetic qualities of the lamp, beyond the vaguely art deco flavour of the heavy stepped base that formed a counterpoint to the skeletal nature of the moving arms.

There were other unresolved issues about the design. The power cable for the Anglepoise, in its earliest version, was wrapped in a braided cloth fabric that was threaded through the structure, spilling out at the joints like a pyjama cord gripped in the claws of a lobster. And since the Terry family were not in the switch making business they used basic off-the-shelf components for the Anglepoise that did the job they were asked to in strictly functional terms, but hardly

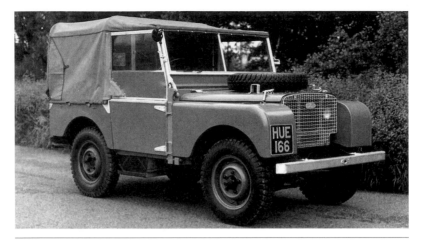

Like so many cars, the Land Rover began as an unself-conscious solution to an engineering problem and then became a brand. In the process the task of the designer switched from invention to something close to breeding rare sheep.

turned the act of switching the lamp on and off into the engaging ritual that it would become.

Despite the makeshift nature of the early versions, the Terry family succeeded in creating something that was more than just another product. Even though it was a new form, it was immediately obvious what an Anglepoise was, and how to operate it. The shape explained itself. And in its directness, it seemed to convey a kind of Englishness – one that continues in the most recent versions of the light, given a fully integrated form for the first time by the designer Kenneth Grange.

Very early on, the Terry family had granted a licence on their patent for another version of the light to be produced by a Norwegian company under the Luxo name. A tidied up, much more polished version of the original, this quickly outsold the Anglepoise itself, and eventually threatened to put it out of business. Grange, who has been responsible more than any other British industrial designer in the last

50 years for shaping the parameters of domestic life in the UK, working on Instamatic cameras, food mixers, electric shavers and high-speed trains, was the perfect choice to update the Anglepoise without diluting its authority and to fight back against the Luxo.

There is another version of the desk-lamp archetype, designed 50 years later, that is everything that the Anglepoise is not. The Tizio is an entirely different product, but unmistakably part of the same species. It was designed by the German architect Richard Sapper, and manufactured by an Italian lighting company, Artemide. It replicates the basic premise of the Anglepoise, though without of course infringing any patents. It too provides a concentrated source of illumination that can be moved up and down to deliver light where it is needed, and pushed out of the way when it is not. It works without using any of the Anglepoise's structural or mechanical principles, although it is hard to imagine it existing in its present form if Sapper had never seen an Anglepoise. Most strikingly, it eliminates most of the electric cables. There is no clutter, just a wire connecting the lamp to the mains supply. The Tizio uses an electrical transformer in its base. Not only does this provide the weight that is needed to make the light robust enough to stand up to movement, it steps down the current to levels that allow the painted aluminium arms of the structure to conduct electricity safely. The light source is quartz halogen, as opposed to the conventional tungsten bulb used by the Anglepoise. The joints are pop-riveted with metal eyes, in a way that suggests the technique used on a pair of jeans to reinforce the pockets at points at which the denim is under stress.

What really makes the Anglepoise and the Tizio so different from each other is the way that the Tizio has been so obviously designed, while the Anglepoise is unself-conscious about its shape. In other words, unlike the original Anglepoise, the Tizio is clearly the product of a designer rather than an engineer. Its two counterbalancing

weights are elegantly curved. The halogen source fits into a carefully shaped cartridge in the form of a parallelogram. The lamp belongs on the desk of an architect or a more than usually stylish scientist. The first Anglepoise, on the other hand, looked as if it would have been most at home in a doctor's surgery, or a maintenance bay in a garage.

Where the Anglepoise seems innocent and artless, the Tizio is knowingness layered on knowingness. When it was launched, in 1972, the praying-mantis silhouette established it as the most conspicuous signal of modernity that you could conceivably sit on a desk. Even the light source was a provocative embrace of what was at the time a new and unfamiliar technology in the domestic context.

The Tizio makes a lot out of a dramatic use of colour. It is black from tip to base, with just a couple of concentrated touches of red applied to the switch – positioned on the transformer base – and at the points at which the arms swivel. As Apple also discovered, black transforms the nature of a domestic object. It is decorative, but at the same time, using black in this context is an unmistakable signal that this is an object that is presenting itself as a piece of serious equipment, rather than something more winsome. The Tizio has a spindly elegance, but its aggressive black aesthetic gives it an unsubtle masculinity. (There is an all-white version which was adopted as a brand signature for department-store cosmetics counters.)

The combination of a black structure with joints marked by red dots is a no doubt entirely deliberate evocation of the same colour combination that was used to highlight the safety catch on the barrel of the Walther PPK automatic pistol. (The all-important initials stand for Polizeipistole Kriminalmodell.) The Walther was originally designed in the 1920s for use by the German police force, and was famously well regarded by Ian Fleming's James Bond. Just behind the trigger guard is a red circle the size of a quarter. It was painted on the side of the barrel, under the safety catch, and was vis-

ible only when the catch was moved in the off position and the gun was ready to fire.

The Walther was designed to be lethal, but also to have a barrel short enough to allow it to be carried as a concealed weapon. The most critical imperative was for the mechanism to be reliable, to be easily reloaded, and to be accurate, even under life-threatening conditions. And of course the user had to be sure that the safety catch was on before tucking the pistol away in a shoulder holster – hence the conspicuous red dot, which helps remove any doubt or ambiguity.

These were demanding enough parameters to meet, but the form of the pistol was also the result of a series of choices, some technical, some aesthetic, and others based on the cultural and industrial norms of the factory system that built it. The red dot on a matt black ground is on one level a straightforward practical solution. But it was also a striking motif – one that entered the visual consciousness of designers, who always work by manipulating and recycling imagery from multiple sources. The pistol is ostensibly a piece of strictly functional design, but it is also designed to look intimidating. The same colour combination was used by Volkswagen for the Golf GTI models in the 1980s, when body and radiator grille were painted two tones of black, with a narrow red line framing the radiator.

The association of a car with a lethal weapon might seem to be somewhat unfortunate, but it has a potent appeal. The red dot/black-paint combination on both the Golf and the Tizio may not look like decoration, but, just as much as an acanthus-leaf pattern in classical architecture or one of William Morris's floral pattern wallpapers, it is intended to provide the cue for an emotional response to the object.

To use red dots on a table lamp is decorative in the same way that embellishing a sewing machine with gold patterns evoking natural leaf forms is decoration. But it pretends to be about function rather than ornament. And it contributes to the Tizio having a faint air of barely

suppressed violence. It is an object that suggests that you can do important things with it – things that go far beyond sitting one on your desk.

The domestic landscape is measured out in archetypes at a scale that ranges from the single-family detached house all the way down to the table, the chair and the plate. The adjustable desk lamp has joined

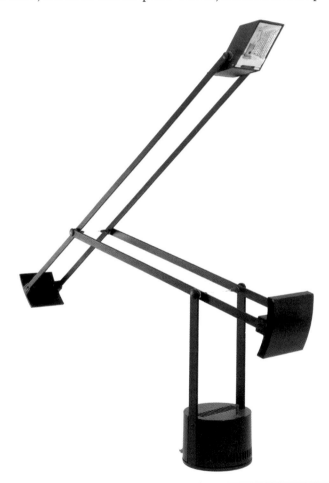

The Tizio's black finish and contrasting red control switch can be traced back to the Walther PPK. It was a colour combination that made the pistol's safety catch as conspicuous as possible. The Golf radiator used red and black to evoke the sinister glamour of a firearm.

them, not in the front row of the essentials of daily life, but certainly as a worthwhile element in the background.

The Anglepoise is a brilliant synthesis of structure and mechanism, creating one of a tiny number of iconic objects that manage to grow into a recognizable brand. The Anglepoise is underpinned not just by its name, but, like Coca-Cola, by an instantly recognizable object that is a physical incarnation of the brand. And it offers a form that will go on keeping designers busy into the foreseeable future.

The Walther PPK has a red dot to show when the safety catch is off. The Golf GTI has a thin red line around the black radiator grill.

But as archetypes go, the Anglepoise is still a relative newcomer. It does not have quite the same universal cultural resonance as, for example, the traditional French wine bottle. The bottle has had centuries to sink deep into the consciousness of the world. It's an instantly familiar form, and one around which so many rituals, both public and private, have evolved.

Countless millions of bottles are made each year, for use in all the expanding number of wine-growing countries of the world. The colour of the glass, the shape, the cork, perhaps held down with a wire cage and protected by metal foil, the graphic vocabulary of the label are all used to manipulate our expectations about the liquid it contains. Try the shock to the taste buds of drinking wine out of a Coca-Cola bottle, or whisky from a beer bottle, to experience the degree to which our perceptions can be shaped by the physical aspects of design.

The bottle is used to signal precisely where the wine is from. French wine bottles are different from German wine bottles. Even within France, different regions have their own bottle styles. And unquestionably there is a mood-setting aspect to the form of the container, the graphic language of the label, and the way in which a bottle is opened. A screw top arouses different expectations from a cork. The classic French arrangement, with label on the waist, a limited range of typefaces, and conventional illustrations that represent a chateau, prepares the palette for something rather different from the vernacular Australian style set by Penfolds, or the more self-conscious modern style of putting contemporary art on a label.

A banknote is another kind of archetype with equally deep resonances. The basic format could not be simpler: a printed-paper rectangle that has a watermark and a metal strip woven into it — devices which make it harder to copy. Apart from a limited range of variable textures and, in the case of the Australian dollar, the use of very thin plastic film rather than paper, there is nothing but the designer's

imagination to work with. But there is an infinite range of graphic possibilities.

With nothing more than an image and a choice of font to demonstrate the probity of a central bank, a banknote has to convince us that it is worth more than the paper on which it was printed. Designing a banknote involves working a complex piece of magic. In part it attempts an evocation of national identity. It is also dependent on other signals of value such as precision, and the quality of production. These shade into the functional intricacies of counterfeit prevention. But there are other messages too. Modernity, for example, is usually expressed by disrupting the conventions of banknote design, and this can be used to serve as a signal of the cultural values of the central bankers who put their signatures on the notes. The Swiss have turned their notes on their sides, and now design them in portrait rather than landscape format. In the days before the euro, Holland went out of its way to make notes that flouted all the usual tics of currency design, culminating in a flaming yellow sunflower that filled one entire side of the 50 guilder note.

But steel engravings still seem to denote a valuable piece of paper with more conviction than, say, a watercolour sketch.

The US dollar has the advantage of some remarkably potent iconography – the all-seeing eye, and that pyramid – so that, in spite of the regrettable tinkering that has recently weakened the currency's once effortless sense of superiority, it still retains a certain aura. It looks valuable because it looks complicated. It looks valuable because all those billowing typographic swirls look so precise and so difficult to draw. It looks valuable because it looks as if it was the product of some kind of semi divine revelation. And, above all, there is the colour. Green is, of course, now the colour of money.

Following in America's footsteps, everybody else seeks to conjure up suitable national heroes whose images, carefully engraved,

Banknotes pose graphic designers the challenge not just of making a worthless paper rectangle look valuable but also of making it look valuable in a specifically British, Swiss, American or European way.

are deployed to convince us that we can safely entrust them with the savings of widows and orphans.

The precise choice of hero is the subject of infinite nuance. In Britain it seems that such figures must almost inevitably belong to the nineteenth century, must be male, and must come equipped with ample facial hair. Both Britain and France used to be more interested in the eighteenth century, but that brought with it the slightly uncom-

fortable need to depict their statesmen, poets and philosophers decked out in wigs.

However, Britain now has the clean-shaven and bewigged Kirkcaldy-born Scot Adam Smith on its £20 notes. An economist is particularly difficult to represent in graphic terms, so the designer incorporates a fragment of text from Smith that is startlingly obscure: 'The division of labour in pin manufacturing: (and the great increase

in the quantity of work that results)' is a curious message to carry around in your wallet, especially when accompanied by a particularly lifeless profile of its author.

The other side, with a portrait of the Queen, focuses on a layered evocation of Britishness. The Bank of England's name is depicted in a flowery Gothic script that deliberately refers to eighteenth-century precedents, but also suggests the way that banknotes used to look in the 1950s, when graphic designers first began to make a knowing use of graphic motifs from the past. The note also carries an early nineteenth-century representation of Britannia, together with four other typefaces from various periods, some modern, others specially designed evocations of the past.

For new states, banknote design is an essential aspect of nation building. Look at the way that the states of the former Yugoslavia rushed to design themselves new banknotes even before they had internationally recognized governments. Out went the heroic steel-workers and apple-cheeked peasant women bringing in the harvest that had once adorned the dinar, like the currencies of so many other worker's states. To present themselves as modern and on the road for full membership of the European Union and/or NATO, they paradoxically choose to look backward to rediscover long-forgotten baroque composers and mathematicians, or in the case of Slovenia the architect Jose Plecnik, to adorn their currency.

At least Croatia and Slovenia had a chance of getting people to take their currencies seriously. Croatia modelled its notes faithfully on the deutsche mark. But you could tell that Macedonia was going to run into problems simply by looking at a national currency decorated with images of white-coated technicians sitting at computer screens, which projected – and had – the financial probity of a tram ticket.

Physical archetypes, or fragments of them, are used in equally sug-gestive ways. The handgun, dating back in its modern form to Samuel

Colt's revolver, and refined in the Walther PPK and the Beretta pistols which followed it, is certainly an archetype. So many objects with completely different purposes make use of its forms, not just its colour. Deliberately evoking the associations of the handgun is to suggest potency and power. By using a trigger in an entirely non-lethal object, the user can acquire the flattering sense of being in command of an object that conveys authority and demands respect.

It is also a clear gender signal, a reflection of masculinity. An actual gun in the hands of a disaffected and otherwise impotent ghetto youth provides a compensating but fleeting sense of power. A trigger, even if it is provided on nothing more lethal than a glue gun or the pistol grip of a vacuum cleaner, offers the domesticated a faint echo of the same sensation, with none of the risk. It is another device which communicates its purpose without the need to explain itself any further.

Archetypes can provide associations in the way that the trigger does. But they can also offer the less specific comfort of a memory, and the complex attractions of a sense of familiarity. By working within the framework of archetypes, there is the possibility of bringing some psychological and emotional depth to the design of objects. Even if our possessions do not age well, and we continually replace them, designs that evoke archetypes offer a consoling sense of continuity. They introduce a ready-made history for an object. This is not the same as a literal recreation of an archaic style: an electric light in the form of a candlestick. But electric light can be designed to suggest the memory of the kind of light we remember experiencing as children.

Any kind of object can offer a soothing quality of this kind. The Moleskine notebooks, with their characteristic hardcovers, rounded corners, slender proportions and built-in elastic band, are to this decade what the Filofax was to the 1980s. Their appeal is not in the neurotic organizing impulse of the Filofax, but in the faint memory that the notebook contains of a simpler past – not our own past neces-

sarily, but a more generic idea of what life was once like even if it never was. On the band that goes round them below the shrinkwrap, they also describe themselves as 'the legendary notebook of Van Gogh and Matisse, Hemingway and Chatwin', and so seem to suggest talent by association.

Design has continually involved creating and organizing archetypes for new categories of objects. Telephones, for example were ad-hoc assemblages of mechanical and electrical parts until Jean Heiberg gave them the characteristic form that still survives in pictograms for telephonic communication. Heiberg was a painter – a student of Matisse and a professor at the Oslo Academy of Fine Art – when he was approached in the early 1930s to design the first Bakelite telephone to be made by the Swedish-based company Ericsson. Objects like this, or Marcello Nizzoli's typewriters for Olivetti, or Oscar Barnack's cameras for Leica, were archetypes, driven by aesthetic ambition as well as by engineering pragmatism. Together they amounted to the basis for a new lexicology of objects for the modern world.

With the rotary dial telephone, each of the elements that formed its basic configuration had been used before. The first telephones had a box with a wind up handle, on top of which was a cradle that in turn supported an instrument that had a mouthpiece at one end and an earpiece at the other. But Heiberg's design marked a point of departure from the past, and put all these elements into a single unified form, moulded from Bakelite. It communicated intuitively how to put it to work. The sculpted form of the handset spelled out exactly where it should be held, which end to apply to the ear, and which was meant to be the mouthpiece. It implied communication in a way that a contemporary cellphone does not. The chrome-finished dial suggested how to operate it without the need for a single word of instructions. Its lack of ambiguity has made the form of the telephone in itself a symbol representing communication. The pictogram representing a telephone is still

based on a dial and a handset even now though these have been super-seded by a small rectangular device without so much as a keypad, now that the iPhone has capitalized on a screen interface for telephony.

There was more than ingenious mechanical and electrical engi-neering at work in the rotary dial. The design of the first modern mass-produced telephone achieved a remarkable balance between symmetry and asymmetry. With the asymmetrical handset arm it had distinctively shaped ear- and mouthpieces poised on a carefully sym-metrical cradle that itself was positioned at the dead centre of the dial. It stayed in production for almost half a century, before technological changes killed it off – but not before a particularly painful transition when manufacturers attempted to fit rectangular digital keypads into a layout devised for a circular rotary dial, fatally undermining the original logic of the form.

It was a form that had created a set of accompanying social rituals to go with it. In my parents' suburban London home the telephone sat on a low table in the entrance hall, presumably so that it was within reach of the entire family wherever they were in the house. Along with the letterbox it was our only conduit through which to commu-nicate with the more distant world. And, in those days of mechanical

The Bakelite rotary dial telephone, originally given its shape by the Norwegian painter Jean Heiberg, is technologically redundant, but it is still the icon for telephony in the digital age.

telephone exchanges, there was only a limited number of lines for the street, so we had to share what was called a party line.

Since this was before the era of central heating, the hall was inevitably cold and uncomfortable – conditions which certainly conditioned an entire generation to approach telephones with extreme caution. Our hall phone table had no chair, so telephoning entailed standing up – another reminder of the respectful treatment that this instrument demanded. Being called to the telephone, as it used to be described, was an uncomfortable experience, and not something to look forward to.

In fact the telephone allowed different rituals to develop in different national contexts. In what sounds like a hand-over from the technological protocols of the Marconi era, Italians still bark the word 'Pronto' into their cellphones in answer to a call. It makes them sound as if they are standing to attention, ready at one end of a primitive telecommunications machine characterized by brass levers and huge dials to receive a message from another operative at the other end of a cable. The British, who now simply use the word 'Hello', once answered their telephones by politely reciting their own number, volunteering their name, and then interrogating the caller with the ritual words 'Who is speaking please?' An equivalent protocol has yet to be established for dealing with the anonymous text. And telephone etiquette has been transformed by the ubiquity of the cellphone. The ring tone of a mobile phone triggers a Pavlovian response in all of us that puts the urge to answer the call ahead of the obligations of politeness to those around us. We are hard-wired to answer, even when we are in mid-flow in a face-to-face conversation.

Though the work of a designer will only occasionally make a lasting mark by creating a new archetype, it is much more often based on the exploration and manipulation of existing archetypes. Once an archetype has been created, it lingers in our minds, a memory ready for reuse, sometimes in very direct ways.

This was what the group of architects and designers who defined the concept of postmodernism in the 1980s set out to exploit. They believed that modernity could not simply abolish history and memory, as the pioneers had claimed that it should. It was an approach that spread from architecture into the design of objects.

The idea of architectural archetypes was well established. In the interests of propriety, a museum should look like a museum, a church should be recognizably a church. Certain architectural styles were associated with certain functions, or qualities. Even at the height of the postmodern eruption, there was still a reluctance to build airports in classical-revival style: the language of the machine age is still understood as providing a certain level of reassurance to passengers nervous about flying. Structures such as these shape the urban landscapes by which we define ourselves, and if we cannot recognize them, we are lost.

Archetypes could also be used to shape the constituent parts of a building. Doors, portes cochères, loggias, and so on create meaning, both practical and symbolic.

They are the signs that show us how to approach and move around a building. They define the public and private areas of a building, their design signifies the structures that are important to a society. Each part has its own meaning, and they can be assembled in different ways to create more complex levels of meaning.

In an analogous way, objects can acquire complexity of this kind by the assembling of components. We are conditioned to understand switches as control points. Keyboards are communication devices. Certain colours signify certain characteristics, that range from gender to precision.

Postmodernism produced a range of architectural projects that were briefly fashionable, subsequently declined into terminal unfashionability, and are now just beginning to emerge to be considered on their own individual merits. At their most earnest and literal, such projects could

look like spare-part surgery, with disparate elements brought together from various periods in the name of memory and resonance. Applied to industrial design and furniture, the results could be just as shrill.

When the American furniture manufacturer Knoll invited Robert Venturi and his partner Denise Scott Brown to design a range of chairs, the result was shriller than most. Knoll is a sophisticated company with a long history of working with high-profile architects, who use their objects as small-scale test beds to put their theoretical concepts into practice. Knoll makes Mies van der Rohe's gloriously patrician modernist evocations of the classical order. But Venturi has made his career out of attempting to demolish Miesian purity with what he presents as a richer, subtler, more allusive approach to design. And by 1986, when Knoll hired Venturi, it seemed as if the postmodern moment had really come.

What Venturi came up with was a series of three-dimensional cartoons that evoke the forms of Chippendale or Queen Anne, or apply

In their own ways, the architects Robert Venturi and Ettore Sottsass both looked for ways to give functional objects emotional resonance by evoking memory. Venturi produced a cartoon Chippendale, while Sottsass rediscovered the innocence of the 1950s.

decorative patterns to bent plywood. They were deliberately trans-gressive. You could see them only as a reference to another moment, in contrast to the modernist idea of approaching design as though nothing had ever been done before.

They were ironic in a sense, in that they were to be taken not liter-ally, just for what they were, but as a commentary, or as a reference to something else. They could also be understood as working within the parameters of the archetype. To sit on a chair that provides you with a cartoonish memory of Chippendale craftsmanship but does not give you the reality of that craftsmanship is curiously mannered, but does lay out the associative nature of design.

At about the same time, Ettore Sottsass, the Italian designer and architect who, when not working for Olivetti, established the Mem-phis group in Milan, was exploring ideas not that dissimilar. In fact he invited another American postmodernist, Michael Graves, and the Austrian Hans Hollein to contribute to what he was doing with Memphis. Sottsass created a series of objects that seemed to be gently mocking the certainties of the modernists. They appeared to delib-erately undermine the idea of order and consistency. Shelves sloped too steeply to support books, expensive TV sets were finished in baby pink to look like toys. Sottsass's own work had been based on a reso-nant exploration of the afterburn of modernity. By the 1970s it had rippled out into Italy's anonymous suburbs, for use in the chrome-plated ice-cream parlours and three-star hotels in tourist resorts, albeit in a vulgarized, faded form. Sottsass evoked this flavour in his new pieces in the 1980s. He detonated a collision between high design and popular culture. The colours, the decorative patterns and the wilfully fragmented shapes he used struck a curiously resonant chord. They seemed to belong to a nonspecific past, or an as yet unclear future.

There is a group of contemporary designers who work within similar parameters but with an entirely different aesthetic vision. They

believe that continually inventing new forms is a distraction when there are so many powerful old ones that still have so much life left in them. They prefer fine tuning to give the archetypes contemporary relevance rather than relentless innovation for the sake of novelty.

The British designer Jasper Morrison and Naoto Fukasawa from Tokyo have both developed an approach to design based on this strategy. They do not directly imitate specific objects, but they do return to archetypes and refine them. Fukasawa, for example, has revisited the calculator. It's a type that has been made almost redundant by the fact that it performs a function readily available on every mobile phone and computer, and many wristwatches. A key piece of office equipment has been reduced to a generic functional property that is given away as an add-on to almost every electronic artefact. But Fukasawa has reconfigured and re-created what is essentially still a useful tool. Rather than compromising its functions, he has returned to the calculator's optimal form and reworked the details to reintroduce the sense of something valuable. He has also returned it to an appropriate scale, instead of miniaturizing it at the expense of usability.

What is interesting about Fukasawa's work and Morrison's, along with that of James Irvine and Sam Hecht, all of whom work closely with the Japanese retailer Muji, with its no-brand approach, is that they began with a visual language that moved them, and they then devised objects that could make use of that language, which were subsequently put into production. This is very different from the designer styling an object that has already been conceived by the manufacturer. It could be seen as an unusual example of the industrial designer as auteur. Though these designers are working with a special kind of anonymity, it is nevertheless one potent enough to have become a distinctive, if discreet, signature.

All this is not to say that it is only the archetypes that matter. Because their functional properties are still in flux, there are other cat-

egories of objects for which an archetype has yet to be created. The cellphone is such a complex and interesting form precisely because it is continually metamorphosing from one shape to another, and promiscuously adding functions.

The same physical object is simultaneously a camera, a conventional telephone and a text messaging system. It can also act as a wristwatch, a diary, an address book, a voice recorder, a music player, a radio and a GPS system. And there are in addition a whole range of other, unintended, roles that it can perform, from an improvised detonator for explosive devices to a means for covertly tracking people's movements. Such ever-increasing complexity is unstoppable, but does little to help the creation of useful, easy to operate products.

A combination of functions is in some ways what the book, another technically much simpler archetype, offers. A notebook needs no instruction manual to operate it. You simply add a sharpened pencil and it becomes a recording device, an agenda, a database and a diary. But the cellphone, if that is even the right thing to call this particular object, is dispensing with a whole range of objects which each had its archetype. The pre-digital-era camera had evolved over 50 years, just as the radio and the wristwatch had done, to produce a well-defined and robust formal language. All the visual clues that these devices once offered to deal with complex functional issues are now absent in their cellphone forms. Operating them depends on mastering an interface which is partly alphanumeric and partly navigational.

Not surprisingly, there are many people who never get past using cellphones simply as absurdly overspecified telephones. The question inevitably arises: are there other shapes that might be more appropriate? It is its sheer ubiquitous portability that makes the cellphone such a powerful device. But this can also be a handicap – not just in operating it, but even in finding it.

The cellphone is perhaps in need of being resolved in another

archetype to express and make legible its multifaceted nature – something like the Swiss Army penknife perhaps, although this is a comparison which demonstrates the essential question mark over the phone. Of course there is a corkscrew included with the various blades on the penknife, but is it really what you would choose to open an expensive bottle of claret? Would you really use the personal organizer on your phone to record all your appointments, rather than the system on your desktop computer? And is that phone the natural place to record your innermost personal feelings, anxieties and pleasures?

But rather than resolving these conflicts, manufacturers are more interested in persuading you that you need one mobile phone for the beach and another for the home, or even that you need one kind of phone to talk to your friends with and another for business calls. Already they have gender-specific models. And the real money is made not by selling cellphones, or from simple phone calls, but from selling all the other things that the phones can be made to do, from downloading ringtones to reading headlines.

The element of playfulness can certainly be one aspect of an archetype. Many toys attempt to present the child's view of the world as a series of archetypes: a house is reduced to a cartoon, or cars and guns become reduced to diagrams. Throne-like chairs for senior executives, and fountain pens as thick as torches, do something similar.

Other uses of a toy-like quality in objects intended for adults stem from the charm of a miniaturized scale. It's an attraction that may well have anthropomorphic origins, in the same way that we are programmed genetically to respond to babies, which are not simply scaled down adults, but have different proportions. A baby's face and eyes are much larger relative to its body than an adult's. It's a proportional relationship that maximizes the emotional engagement of eye contact, which adults – presumably better able to take care of themselves – do not need to the same extent. A tiny hand or foot is likely

to melt the least sentimental adult heart – a useful quality for a young creature aiming to maximize its chances of survival, and so likely to be encouraged by genetic selection. It's also a characteristic that Walt Disney understood when he scaled down the buildings on Main Street in Disneyland to play up their cuteness quotient.

And, as with the Nissan Figaro and the Renault Twingo, you can see the same strategy at work in the way that some motor cars are proportioned. You cannot of course actually pick up a car, but there are some cars that look as if you might be able to, and these are the ones that have the quality of seeming to be engaging. And it's not just cars that are given faces. The use of human or animal characteristics is an underlying theme of much product design.

Apple treated the first iBook as a toy for adults. The soft outlines gave it a cute appearance, and made what was conventionally regarded as a serious piece of business equipment look playful through deliberately surrealistic use of an unexpected visual language. The glowing light around the power socket gave it the character of a domestic pet. The ambiguous rubbery transparency suggested a kind of New Age vulnerability. The clear plastic triggered a paradigm shift. Because it was so different from anything else on the market, the iBook instantly became a visual prop in advertising imagery, shorthand for cutting edge. Every company struggling to show that it hadn't been left behind in the steam age would buy a couple of iBooks to put on its reception desks, just as it would once have used the Tizio light to show that it was purposeful and efficient. Makers of everything from pocket calculators to audio equipment started coming out with products in rounded transparent plastic and citrus colours.

Toys need not just to look cute. They need to offer at least the possibility of a degree of playful interaction. Buttons to press that can give a satisfying sort of a click when touched do that. So do switches that reveal a flash of colour when moved up or down.

These are relics of the mechanical era that is already passing, but they have their equivalents in the screen world. As machines use fewer moving parts, and develop less mechanical operating systems, these former aspects of objects are introduced in new and different ways. The sounds that a machine makes can become much more carefully calibrated when they are based on digital methods. The camera function on a cellphone, for example, triggers the sound of a shutter – an evocation of a technologically redundant function which will soon mean nothing to a generation that has never known film photography or heard the mechanical sound on which the digital version is based.

Design is understood as a primarily visual language. It uses colour to suggest playfulness or masculinity, and shape to engage or inform users about functions. But it is much more than that: it makes use of all the senses. The smell of leather or wood or ink transforms our responses to a car or an interior or a book fresh from the printer. Fragrances are prepared with the skill of generations of experts to convey a wide range of messages, relying on associations based on memory. The soft touch of fabric, the coldness of metal, the quality of travertine that has been warmed in the sun, the sound of a keyboard in use or a switch operating, or a camera shutter, have also come to take on symbolic qualities which are considered and manipulated as much as any visual signal. Preparing food and making wine are not generally described as design, but they are very closely related to it. And our sense of taste determines our responses to so many objects – not least the china or the glass that we use for our eating utensils.

The most successful designs are those that make simultaneous use of all of these qualities, and do it with a conscious understanding of what they can do.

3 | LUXURY

'LUXURY,' THE ARCHITECT REM KOOLHAAS ONCE claimed, 'is stability.' Picking up speed in his usual declamatory way he went on to deliver himself of a manifesto: 'Luxury is "waste". Luxury is generous. Luxury is intelligent. Luxury is rough. Luxury is attention.' The style may be more suggestive of a copywriter with a fragrance account than of the most respected architectural theorist of his generation, but he concluded, unarguably, that 'Luxury is not "shopping".'

Actually, the bulimic fluctuation between gratification and self-disgust that comes from the compulsion to acquire too much too fast is exactly what luxury has become. It wasn't always like that. The shopping phenomenon is the result of an enormous

and very recent acceleration in the rate at which we consume. Luxury has had other meanings in the past.

Luxury used to be the respite that mankind found for itself from the daily struggle for survival. Luxury was the pleasure to be found in understanding the quality of material things that were thoughtfully and carefully made. It was the aspect of an object's nature that allows us to share the pleasure that it gave its designer or its maker. It was a reflection of intelligence, as well as of tactile sensations.

The solace that luxury could offer is what encouraged even the most brutal and violent of despots to underwrite scholars and craftsmen and artists to create it. It is because of the resources they demanded that it is a quality that also became a signal of status, distinguishing one social group from another.

Scarcity can make luxury from the simplest of things. Luxury in an age of abundance is harder to get right. When the alternative is a hand-drawn well half a kilometre away in the blistering sun, an electric pump, a reliable power supply and a length of plastic pipe can bring a whole community the previously unimaginable luxury of a constant supply of water. But when the pump is running 24 hours every day, and each tap in the village is primed to deliver clean water at any moment, then a remarkable privilege no longer seems like luxury. It has become the most basic of entitlements, and to lose it is to be brutalized.

Yet compare the sensation of a mouthful of pure chilled spring water, taken from a stream splashing across a rock face, with the more mundane experience of filling a tumbler from the tap. Provided that it is a choice freely made, rather than an inescapable daily necessity, that gulp is the more intense and emotionally charged and, it might be said, far more luxurious experience of the two.

The contemporary manufacture of luxury is based on creating objects in a world of tap water that can artificially replicate the experience of the stream. Its primary target is the expanding class of the

affluent. In *Ways of Seeing*, John Berger divides the world in two: those whose economic role is first to labour and then to consume, and those who employ their capital to exploit the people in the first category. Berger suggested that the rich had won themselves a respite from the obligation to become dutiful consumers. He claimed that they don't have to put up with the advertising that the rest of us must endure, since they are left to use their wealth as they choose. This is hardly a reflection of the world as we now know it. The numbers of the hugely wealthy have exploded, and, as a result, luxury has expanded unstoppably from a craft into an industry, partly to accommodate their tastes, but also to feed on their wealth.

The pursuit of luxury is more ubiquitous now than at any previous moment in history. In the absence of scarcity, luxury has acquired a role beyond its use as a coded social signal of privileges. In 2007 Selfridges, the London department store, spent £25m on transforming most of its ground floor into what it calls the Wonder Room, an entirely deliberate reference to the *Wunderkammer* – of the seventeenth-century collectors and the Pitt-Rivers Museum in Oxford, which mixed religious relics with botanical specimens. The department-store version is a museum in which everything is for sale, and where burly Russian-speaking men in suits ensure that the customers pay for the exhibits before they leave the premises. You can see rack upon rack of claret – the Château Lynch-Bages starts at £550 a bottle. There is an ancient green pound note bearing the signature 'Ronnie Biggs, Rio', on sale for £750, a diamond-encrusted laptop, for £33,300, and a bar full of Vertu cellphones at £3,000 each. There are Perspex handbags that you can't open, with prosthetic devices inside – the work of a Dutch designer – and vases designed by the architect Zaha Hadid. The ground floor of a department store conventionally gives most of its space to fragrances – they offer the best mark-up in relation to their price. But the Wonder Room feels confident enough to plant its huge

open prairies with case upon case of wristwatches. They offer an even better margin, provided there are enough customers prepared to pay £5,000 for a chronograph as opposed to £120 for a bottle of scent.

At a secular moment, in which neither magic nor religion – the original mainsprings of art – has quite the prestige that it once enjoyed, luxury can be understood as a synthetic alternative. For certain objects, the concept of luxury is used to create the aura that art once provided. You do not have to believe in God or in magic to be seduced, in however minor a way, by a banal version of luxury. But, to judge by Koolhaas's messianic tone, luxury itself may yet become a religious cult. Certainly luxury has become the driving force fuelling Western industrial economies. They have abandoned basic manufacturing to China, and focus instead on building cars that reek of carefully tanned leather and whose heavy doors click shut reassuringly softly. Europe is in the business of making expensive clothes and luggage, wristwatches of impossible precision, and military aircraft made from exotic carbon fibre and alloy that are capable of flying at the speed of sound.

Each of these is a conspicuous luxury of a kind. Strictly speaking, we don't need any of them, and yet if we didn't make them and then buy them, the economy on which we depend for our survival would suffer, so in a sense we certainly do need them.

But luxury is an ever more elusive concept in the contemporary context. It is harder and harder to make an object that feels sufficiently out of the ordinary to qualify. The wonder is that the concept has survived at all, when there are so many more possessions and they are so much easier to make than in the past, when skills were jealously guarded secrets, passed from generation to generation. It's even more remarkable that luxury has managed to retain its allure, given the archaic nature of so many objects that are notionally its embodiment. It seems to be easier to imbue categories of object that are on

Luxury in a technologically driven period of turbocharged obsolescence is a complex quality to address. Studding a laptop with diamonds seems a curiously ineffective way of charming its owner. Wristwatch manufacturers have been clever at holding on to the mirage of an object that still spans generations.

the brink of redundancy with the quality of luxury than to create new ones that can demonstrate it.

Yet the theory that Britain tampers with tradition at its peril, because of its economic potential, suffered a near-fatal blow with the collapse of that quintessentially British bank Barings. The sight of tradition at work, whether it is curiously kitted-out men ringing bells at Lloyd's or the pink tailcoats affected by the Bank of England's doormen, is now interpreted as a warning sign. Before Barings went

down, the patina of lovingly crafted panelling, polished brass and worn leather that its name continued to suggest spoke quietly of quality and reliability. Now the same visual clues urgently suggest exactly the opposite.

For luxury to survive, the traditions on which it depends, far from staying the same, need to be continuously reinvented.

Some objects are more redundant than others. The wristwatch still retains its prestige. But the fountain pen is losing the attraction it once had. For a while, the pen was presented as more than a practical writing implement. It was a possession that could be passed from father to son – the kind of industrial object that might form part of an atavistic coming-of-age rite. The protective cap could be unwound slowly and reverentially to reveal a sculpted gold nib. The proportions were satisfyingly commanding, and would be made even more so by placing the cap on the end of the barrel. There was a clip on the cap to discreetly signal the presence of the pen even when it was concealed in a jacket top pocket.

It is now on the brink of the same fate that befell the portable typewriter. The basic concept has lost its relevance. Keyboards have sharply reduced opportunities to demonstrate elegant handwriting. Pens still have those clips, because that is what they have always had, but fewer and fewer people want to risk them in a jacket pocket – ink reservoirs and traditional nibs are notoriously prone to leak over hands and clothes. Ballpoints are a less risky alternative. But, even when equipped with a barrel just as glossy, and a cap identical to that of a fountain pen, the ballpoint version of a brand has nothing like the same charisma and fails to command the same premium price no matter how many gold carats it is finished with.

The wristwatch, in contrast, has been able to maintain its position as a desirable artefact in very much the same shape that it assumed at the start of the twentieth century when Cartier first started to make

them for men, followed shortly afterwards by Rolex. The traditional wristwatch has managed to see off the eruption of quartz technology despite a wobble over the introduction of digital as opposed to analogue faces, mass-produced accuracy, and the impact of fashion as exemplified by the Swatch phenomenon.

What makes the wristwatch different from the pen is that its form was born from a collaboration between jewellers, who made the cases, and mechanical-movement makers, who in the early days supplied the working parts. Jewellery has a long history of addressing the emotional and tactile interaction between people and things. This is an interaction which every kind of personal object must succeed in if it is to acquire an emotional resonance, but few manage it.

Certainly archaic technologies do have their appeal. Enthusiasts for mid-twentieth-century recording technology have kept the vinyl disc alive. And there are manufacturers who have gone back to the use of vacuum tubes rather than solid state circuits for amplifiers. But the charming easily tips over into the preposterous. When digital readouts increasingly replace the dials and instruments on the dashboards of cars, how can a walnut fascia designed as the backdrop to carefully delineated sets of dials be made to accommodate them convincingly? When this is attempted, walnut turns into an anachronism, not an asset. It signals not luxury, but pretension.

Because the cellphone is permanently in the hand, and close to mouth and ear, it has a relationship with its user as intimate as any they will have with a wristwatch. The visual interface, the sound made, the mechanism that protects the keypad offer plenty of scope for a designer to give cellphones a personality. But when their makers have attempted to produce what they call luxury products they have had a much harder time of it than the watchmakers. The usual strategy has been to use precious metals and stones in the most conspicuous way possible. But a gold-plated case for an object that is technically redundant after six

months looks gratingly profligate even in the midst of a culture of excess. Rather than gold adding lustre to the phone, the phone undermines the prestige of gold as a material when it is used in this way.

Attempts at creating what are called luxury laptops have been equally futile. Wooden keyboards, leather cases or even carbon-fibre shells have simply looked inept. It's the speed of the hard drive and the effectiveness of the operating system that make us warm to a computer, not the appropriation of anachronistic materials in an attempt to give it a personality.

Luxury used to be understood rather differently. When, in 1754, William, fifth Earl of Dumfries, commissioned Thomas Chippendale to design fifty pieces of furniture for him, he wanted something that could take in its stride the ruthless but beautifully symmetrical precision of the new house that the Adam brothers were building for him. He also wanted a collection of luxurious objects that could be read on a variety of levels. Their ostensible functional purpose was only one aspect of the commission. The Earl's specifications included chairs to dine on, writing desks to sit at, and beds to sleep in. These were all tasks met perfectly adequately by the somewhat different, and considerably cheaper, set of objects used to furnish those parts of the house used by Dumfries's servants. But Dumfries wanted something more.

Chippendale's work, in contrast to the below-stairs furniture, was intended to demonstrate the wealth and power of the family that commissioned it, their connoisseurship, and their pedigree. It was the embodiment of luxury in fact, designed, in the phrase that made Thorstein Veblen's book *The Theory of the Leisure Class* (1899) so famous, for the purpose of 'conspicuous consumption'. For the leisure class, objects that were designed to be consumed in this way were not things that their owners had to have in order to live comfortably. Rather they were owned in order to demonstrate being in a position to have and to appreciate them.

Robert and John Adam built Dumfries House and commissioned Chippendale to design the furniture. The broken-pediment bookcase and the rest of the house's furniture were on the verge of being auctioned with a reserve substantially higher than for the whole house and its accompanying land, suggesting how low down the cultural pecking order architecture now finds itself. Following in a line from Vitruvius and Palladio, Chippendale produced a lavish guide to his designs, as both a manifesto and a sales brochure.

Such objects, Veblen suggested, need not just to be inherently beautiful: they also have to be understood as looking beautiful if they are to achieve their purpose essentially as peacock tails. Simply looking expensive is not enough. Signalling value and ambition needs to be done in the right way. With certain kinds of object, you need to know a little about them to understand just how precious they really are. Not everybody can be an insider. That was the point: the people to whom Dumfries wanted to communicate a message through the medium of his new house and its contents would understand what they were looking at. In exactly the same way, bike couriers use a short length of chain to hold down their saddles not just because saddles are so expensive to replace, but to signify belonging to a group. It's a group whose members believe that brakes spoil the look of their machines, and who abhor derailleur gears. They understand the occult language of initiates, and they know what makes apparently identical machines so different from each other.

The world is made up of limitless numbers of groups of such initiates. There are those who have become obsessive about sunglasses in a way that comes close to high-functioning autism. These are people who expect you to know that their specially made frames come from the same Italian workshop that made the pair that Steve McQueen wore in *The Getaway* before they take you seriously. And there are snowboarders and surfers, motorcyclists and music buffs, hunters and fishermen all of whom have their own subcultures defined in terms of objects and the expertise that goes with them, just as there are contemporary enthusiasts for the work of Chippendale who undoubtedly know a great deal more about it than Dumfries did.

Chippendale embodied aristocratic restraint in his work. He preferred carefully proportioned objects to over-elaborate embellishment. But he did make use of precious timbers, shipped to his workshop from across the world. The breakfront book case for Dumfries House, for

The fetish for objects, their provenance and their associations, exemplified by Steve McQueen's sunglasses, are the starting point for the drooling pornography of collecting.

example, with its integral writing drawer, was made from three different kinds of timber: rosewood, padouk and sabicu. Few people would have been able to recognize any of them, but then very few people in eighteenth-century Scotland would ever have got to see any of Dumfries's furniture. On the other hand, the kind of people that the Earl

invited into his home could reliably have been counted on to understand that the relative decorative understatement of their host's furniture was an aesthetic choice, denoting confidence rather than an enforced economy. And the house itself would certainly have helped get the message across.

Chippendale was no less exotic in his sources of inspiration than in the forests that supplied his workshop with timber. He designed a pair of Chinese-style mirrors for Dumfries House with pagoda crestings, flanked by a troupe of moustachioed orientals. The chinoiserie style of Chippendale's early career reflected European fascination with what was seen as the exoticism of the East. It also suggested that Dumfries was interested in the modern world, a man of fashionable discrimination.

The rococo palm winged four-poster in mahogany, supplied for the blue bedroom, came with blue and gold festoons. And, 250 years later, bed and festoons are still there. In itself, such a degree of longevity is a powerful sign of the self-confidence of a family that can make its own rules about taste, and live outside the definitions of fashion. In 1759 Chippendale charged £90 11s 0d for the bed – more than enough to build a home for one of Dumfries's estate workers. The bookcase, which had cost Dumfries substantially less than the bed when it was new, was offered for auction in 2007 with a reserve of £4m.

As Veblen put it:

The utility of articles valued for their beauty depends closely upon the expensiveness of the articles. A hand-wrought silver spoon of a commercial value of some ten to twenty dollars is not ordinarily more serviceable than a machine-made spoon of the same material. It may not even be more serviceable than a machine-made spoon of some base metal, such as aluminium, the value of which may be no more than ten cents. If a close inspection should show that the supposed hand-wrought spoon

were in reality only a very clever citation of hand-wrought goods but an imitation so cleverly wrought as to give the same impression of line and service to any but a minute examination by a trained eye, the utility of the article including the gratification which the user derives from its contemplation as an object of beauty would immediately decline by some eighty or ninety per cent, or even more. The superior gratification derived from the use and contemplation of costly and supposedly beautiful products is commonly in great measure a gratification of our sense of costliness, masquerading under the name of beauty. The requirement of conspicuous wastefulness is not commonly present, consciously, in our canons of taste, but it is none the less present as a constraining norm, selectively shaping and sustaining our sense of what is beautiful, and guiding our discrimination with respect to what may legitimately be approved as beautiful and what may not.

In Veblen's terms, Dumfries's furniture has come to represent consumption on an ever more conspicuous scale in the two and a half centuries since it was made.

It was not just the furniture at Dumfries House but the entire building that could be regarded as a trophy. The reason that the house survives in anything like its original state is that it was never a primary family home. Dumfries died childless, and the estate passed to the Bute branch of the family, who had their own seat at Mount Stuart. The Butes made a fortune from Welsh coal, but, with the bleak traces of the Industrial Revolution lapping at the gates of Dumfries House, which stands in the midst of the spoil tips of the Ayrshire coalfields (with the birthplace of Keir Hardie, founder of the Labour Party, just a few miles away), they preferred not to live there. It is benign neglect that has kept the house in much the same state as it was when it was new.

Chippendale's furniture was intended to animate the architecture of the house's fine rooms, which is why, 250 years later, when the seventh Marquess of Bute decided to get rid of the house, the land on which it stands, and all the furniture he had inherited, there was an indignant campaign to keep them together. As if to demonstrate the extraordinary attraction of a readily portable object when set against less movable works of art or architecture, the estate agents marketing the house set an asking price of £6.75m for the building and the 2,000 acres that went with it, while the furniture was to be auctioned with a reserve of £14m. The issue was finally resolved when the Prince of Wales loaned the National Trust for Scotland the money to buy the house and everything in it.

The fact that the Prince embraced the cause of Dumfries House demonstrates the rather different position that a Chippendale chair occupied in 2007 from the status it had as a fashionable object when it was new. Chippendale had become synonymous with tradition rather than luxury. As if to underscore such fluctuations in taste, the current Marquess of Bute prefers to invest in commissioning contemporary designers such as Jasper Morrison to work for the Bute textile factory. And his father had clashed with the Prince of Wales in his determination to build a new National Museum of Scotland in Edinburgh in contemporary style. The Prince resigned from the museum's fund-raising committee when the museum refused to let him veto its choice of architect.

The most provocative question about Dumfries House now is why there should be such a powerful, if sentimental, connection between architecture and furniture. It is true that content and container were conceived of as all of a piece. As the architectural historian Mark Girouard has shown, social life in a country house in the eighteenth-century was conducted as an intricate set of rituals. The architecture of the house was the stage, the furniture was the scenery. And the dialogue between them was the setting for much more than the domestic

The carefully documented clutter on Freud's desk testifies to a lifetime's contemplation of the psychological resonance of accumulating objects.

life of the family. So much was familiar from the way that every earlier culture had understood and made use of luxury. But in Chippendale's day furniture was not an architectural element in an interior. It was there to be moved as was convenient, rather than rooted to the spot. But the significance of Dumfries House today is in the store that is set on keeping house and contents together. It is partly because the combination of the two reinforces the sense of their authenticity. But it also suggests an attempt to show that it was Dumfries, not Chippendale or Adam, who was the true creative genius responsible for the ensemble.

There are individuals who have made collections of objects that have a genuine resonance. The surface of Sigmund Freud's desk, for example, was cluttered with the traces of his lifelong passion for the acquisition of classical sculpture. He brought the collection with him

to England when he had to flee Nazi-controlled Vienna, and took the trouble to have it photographed *in situ* before leaving. The images provide an insight into a mind that used the shattered traces of classical perfection as a metaphor for his exploration of damaged personalities, which he tried to understand by looking back to their past.

Other collectors are less interesting. The politically well-connected Armand Hammer had the egotism to christen a Leonardo manuscript the Codex Hammer simply because he briefly owned it.

Dumfries, who had been a soldier attached to the general staff of King George II at the Battle of Dettingen, was also a scientist and astronomer and clearly a man of varied accomplishments. His possessions could be seen as offering an insight into his achievements. But he wasn't Freud. It was Chippendale's work that marked the genuine point of departure, rather than the commission.

The historical traces that Bill Gates will leave behind him are of a different nature from those of Dumfries. It's not very likely that they will include the furniture in his house outside Seattle, despite the best efforts of his decorator, Thierry Despont. Gates or Larry Ellison or any number of dot-com and hedge-fund billionaires or Russian oligarchs might well commission Marc Newson or Philippe Starck to build their bathrooms or decorate their Gulfstream jets. But beneath the marble, the paint and the Naugahyde upholstery it would be exactly the same as every other spa or Gulfstream. And if these designers were to be commissioned to furnish a house, there is no sign that they would achieve anything to match the scope and creativity of the combination of the Adam brothers and Chippendale.

Perhaps only the yacht-building mania among today's super-rich comes close to combining the scale and the quality of what their predecessors tried to achieve. The obsession of Roman Abramovich with boats and size has driven him to commission the building of a ship 500 feet long, in much the same way that some of his fellow billionaires

are fighting to build the world's tallest skyscraper. Aesthetically more impressive, but equally indulgent, is the America's Cup phenomenon, with a circle of the wealthy funding boats of genuine beauty, built in the service of speed, and ego, and with an ambition for excellence that Chippendale would certainly have recognized.

Chippendale produced a portfolio of his designs under the title of *The Gentleman and Cabinet Maker's Director,* a beautifully engraved, self-published sales brochure. In it, he offered a set of objects in a variety of styles and degrees of elaboration that his clients could choose from or, if they had a mind to, adapt to suit their own tastes. It was a marketing strategy that could previously be contemplated only by architects with deep pockets. In this sense Chippendale was a pioneer in the emergence of design as a distinct aspect of the manufacture of objects. The *Director* started a trail that would eventually lead to the Habitat catalogue and IKEA.

Chippendale could also be seen as a pioneer in brand creation. The lustre of his name extended to cover the work of many craftsmen working in a network of workshops. This not only expanded to include his son, who eventually took over the business, but also, through the design templates published in the *Director,* provided a model for workshops as far away as America. But Chippendale never got as far as the kind of brand extension that has become such a significant aspect of the contemporary luxury industry. Luggage makers such as Prada and Gucci have moved into fashion, and jewellers and watchmakers apply their names to perfume. Even the Ferrari automobile marque is used as a badge on premium priced garments.

Like Chippendale, Terence Conran, the founder of Habitat, may not have been the most original designer of his time. But he has certainly been the most influential. What really makes Conran stand out is the way he has been able to create a way of life that other people want to live. It is the world according to Conran, an attempt to make ordinary,

banal places a little out of the ordinary. The Habitat catalogues encapsulated that world, and made us all feel as if we were putting our noses to the glass to peep in on somebody else's Christmas. Even from the other side of the glass it all looked so attainable. It's about dreams, of course: France as we would like it to be, not the way it really is, and of family life as it ought to be. In the Conran living room, bright new plastic chairs can sit comfortably next to junk-shop finds and the occasional antique.

Habitat began as the style of choice of the strapped-for-cash student and the young professional setting up home for the first time. And bit by bit, in almost imperceptible stages, it elbowed aside what had gone before to become the signature style of grown-up Britain. This generational shift had its apotheosis on the night that the Blairs

took Bill and Hillary Clinton for dinner at the Pont de La Tour, Conran's Thameside restaurant. But of course Habitat has now also taken on some of the aura of a period piece, retreating in the face of another generation's tastes.

Conran showed how the lingering taint of Utility furniture, coin-in-the-slot gas fires and bath times limited to three inches of hot water per person could be dispelled with a coat of orange paint, a floor sander and a scattering of dhurries. It was the living room in his Regent's Park Nash terrace that got pride of place in the *House Book*, Conran's answer to Chippendale's *Director*, which went into ten editions between 1974 and 1983. The room is painted a careful shade of buttermilk. The floorboards are stripped, of course. In the

Terence Conran offered his own home in the Habitat catalogue as the model for his customers. The catalogue gives a deadly accurate insight into the tastes and aspirations of the metropolitan British middle classes throughout the 1970s and 1980s, just as Chippendale set the pattern for the country house of the eighteenth century. While retailers have traditionally shifted to accommodate the tastes of their customers, IKEA has stuck to its guns, using their advertising campaigns to persuade the British to 'chuck out their chintz'.

background, a striking contemporary painting hangs over the original marble fireplace. A fire burns in the grate, fuelled by an outsize wicker log basket. There is a Vico Magistretti-designed chair at the table, while the outsize sofa is flanked by a pair of Mies van der Rohe chairs and a flock of giant floor cushions covered in striped fabric. A spotlamp sits on the coffee table.

IKEA's approach to taste is more imperial. Conran left you to make up your own mind. IKEA's strategy in every country in which it has established a presence is to refuse to budge a single millimetre from its tested formula. Its products are all given Scandinavian names, the café serves Swedish meatballs, and the taste is IKEA's, not that of its customers. In Britain, rather than adapt its product line to local taste, IKEA launched an aggressive advertising campaign aimed at modifying the supposed national fondness for floral fabrics. And it has brought the take-it or leave-it customer-management techniques of an aggressive budget airline to retailing.

Chippendale was less self-confident. He felt the need to use the pages of his book to rebut what he called the calumnies of malicious rivals who claimed that some of his designs were impossible to make, that the creative imagination and the narcissism of the designer were overtaking the skills of the maker. Design presented a chance to exercise the ego in a way that craft did not.

For Dumfries there was no other standard by which to measure luxury but the protocols of handcraft. Padouc wood might be an exotic form of timber, but it wasn't polycarbonate. It was still a material with characteristics that a skilled craftsman could deal with. Until the middle of the nineteenth century, luxury was still a phenomenon inextricably linked to the idea of handcraft, either through the survival of traditional practices and techniques or else in the way such techniques and aesthetics were the starting point for imagery that the new industries attempted to copy.

But the reverse then became true. Even though the most influential voice shaping ideas about design in the nineteenth century was William Morris, who regarded the Industrial Revolution as an unmitigated evil that undermined craft traditions by churning out mechanical copies of the creative achievements of traditional makers, people could not help but have their visual preconceptions recalibrated by the shapes and finishes that characterized machine-made mass production. When the British first saw the handguns that Samuel Colt was making, they were shocked by the technical facility with which they were produced, but also by the naked simplicity that Colt's modularized manufacturing encouraged. There was nothing further removed from the decorative treatment of the walnut-stocked, hand-engraved barrels of a British shotgun.

Objects such as Colt's handguns and the industrial production of furniture pioneered by the Thonet family with their bentwood techniques demonstrated the need to develop a new language for design, and a new way of fulfilling people's taste for luxury. It had to be a language that could adapt to the changed realities of mass production.

Even if the social and cultural context was entirely different, the impulse driving Dumfries to commission the Adam brothers to build his house, and Chippendale to furnish it, was very much the same as that behind the Austrian millionaire Fritz Waerndorfer's compulsive spending on the craftsmen of the Wiener Werkstätte at the start of the twentieth century. The industrial world that was visible only in the faintest outline in Dumfries's day had by then become inescapable. Henry Ford was already preparing his production line at Highland Park for the Model T that he would launch in 1908.

Working through the Werkstätte, Josef Hoffmann put craft to work in new ways. He employed newly developed materials, including aluminium, that seemed to have been deliberately chosen to signal a break with the past. The result was a collection of domestic objects

such as tableware and ornaments that still had a traditional social role – offering their owners the solace of possessions endowed with emotional resonance in much the same way that Dumfries would have understood Chippendale's work – despite a radically different design language.

The members of the Werkstätte were still equivocal about industrial production. They claimed that they were more interested in finding an authentic voice for the craftsmanship of their own time than in designing for industry. Hoffmann's manifesto proclaimed, 'Even we are aware that a mass-produced object of a tolerable kind can be provided by means of the machine: it must however then bear the imprint of its method of manufacture. We do not regard it as our task to enter upon this area yet.' But Hoffmann's baskets and candlesticks, made from folded sheets of metal pierced with relentlessly regular grids, and with a complete absence of any other form of applied ornament, certainly made it look as if the Werkstätte was creating an aesthetic vocabulary specifically suited to making the best of the capacities of mechanical production.

This was an important shift away from William Morris's implacable hostility to machinery in all its forms. While Morris looked back to a pre-industrial period as the inspiration for his work, the Viennese looked forward to something new:

> The immeasurable harm caused in the realm of arts and crafts by shoddy mass production on the one hand, and mindless imitation of old styles on the other has swept through the entire world like a huge flood. We have lost touch with the culture of our forebears and we are tossed about by a thousand contradictory whims and demands. In most cases the machine has replaced the hand and the businessman has taken the craftsman's place. It would be madness to swim against this current.

Usefulness is our first requirement and our strength has to lie in good proportions and materials well handled. We will seek to decorate but without any compulsion to do so and certainly not at any cost. The work of the art craftsman is to be measured by the same yardstick as that of the painter and the sculptor.

At the same time, the Werkstätte made a powerfully seductive argument for what might be understood as the concept of luxury in a modern sense:

The machine works away diligently and fills our bookcases with ill-printed volumes, its criterion is cheapness. Yet every cultured individual should feel ashamed of such material abundance. For on the one hand, ease of production leads to a diminished sense of responsibility, while on the other abundance leads to perfunctoriness. How many books do we genuinely make our own? And should one not possess these in the best paper, bound in splendid leather? Have we perhaps forgotten that the love with which a book has been printed,

Josef Hoffmann and Koloman Moser established the Wiener Werkstätte in a concerted attempt to beautify the objects that form the background to daily life.

decorated and bound creates a completely different relationship between it and us, and that intercourse with beautiful things makes us beautiful?

It is as powerful and, it might be said, narcissistic a justification for the modern cult of luxury as you could hope to find.

Waerndorfer spent as lavishly on the company he founded with Koloman Moser and Josef Hoffmann to make the furniture and domestic objects that they designed as he did on himself. He equipped his Vienna home with a music room designed by Charles Rennie Mackintosh, a dining room by Hoffmann, and a picture gallery by Moser to display his collection of Aubrey Beardsley prints and his Klimt paintings.

Owning a Werkstätte product was the badge of belonging to a certain kind of cultural elite. If you wanted to be like Gustav Mahler, the King of Bulgaria or the Stocklet family in Brussels, you just had to have a set of Wiener Werkstätte napkin rings. Except, of course, that you couldn't really stop with just a napkin ring.

The simplicity and the startling originality of the Wiener Werkstätte's approach to designing domestic objects certainly helped to define contemporary culture, but the business was never a financial success. Hoffmann's perfectionism did not help. He was notorious for taking a hammer to objects that failed to come up to his exacting standards, and sending them back to the unfortunate craftsman responsible to be remade. It pushed up costs. And many of the pieces made for sale on consignment failed to find customers and came back unsold.

Waerndorfer ended up going bust and became a farmer in America. The Wiener Werkstätte went through two more final crises before it finally collapsed.

Our relationship with luxury is not the same as it was in Dum-

fries's pre-industrial era, or, given the huge expansion in the number of possessions that the average household has in its cupboards in the last 50 years, in Waerndorfer's version of the modern world either.

Whether he knows it or not, a footballer will buy a Louis Vuitton bag or a Patek Phillipe watch, perhaps from the Selfridges Wonder Room, for the reason described by Josef Hoffmann: because we believe that owning beautiful things makes us beautiful too.

What constitutes luxury in a modern sense is not easily defined, however, particularly since luxury and modernity can be seen as mutually antagonistic. Luxury is elitist, and potentially based on the cultivation or at least an appeal to the idea of tradition, whereas contemporary rhetoric suggests that modernity is egalitarian, democratic and inclusive. And modernity appears to be iconoclastic, and to set itself up as a counterpoint to tradition. In fact the relationship is not the simple duality that it might seem, given that luxury has now become such a key Western industry: premium-priced goods are mass-produced.

Adolf Loos, who shared café tables in the last days of Habsburg Vienna with Hoffmann and Moser, provided a few pointers to what luxury might be in his newspaper columns. Loos was a designer and architect of genius. And he was also a brilliantly acerbic critic.

The evolution of culture is synonymous with the removal of ornament from objects of daily use. What makes our period so important is that it is incapable of producing new ornament. We have outgrown ornament. But there are hobgoblins who will not allow it to happen. Humanity is still to groan under the slavery of ornament. Man had progressed enough for ornament to no longer produce erotic sensations in him unlike [with] the Papuans, a tattooed face did not increase the aesthetic value, but reduced it. Man had progressed far enough to find pleasure

in purchasing a plain cigarette case even if it costs the same as one that was ornamented.

Beethoven's symphonies would never have been written by a man who walked around in silk, velvet and lace. The person who runs around in a velvet suit is no artist but a buffoon, or merely a decorator.

The relationship between luxury and handcraft – always a complicated one – has shifted since the time of Veblen. Craftsmanship has come to be associated with the idea of taking care, while industry suggests standardization. Traditionally, luxury was signified by conspicuous or elaborate workmanship, and costly materials. Something that was difficult implied scarcity, and an investment of time and effort.

We used to know what mass-produced looked like, and what was handmade. This allowed certain forms or materials to come to mean luxury. But industrial production makes objects that handcraft cannot: the difficult has become easy. And if luxury is based on scarcity or difficulty then, once the effort has been stripped away, so is the luxury. Also, by any objective criteria, machines can make most things better than people can, and our eyes, and our hands, have become habituated to the standards of finish that machines can provide. The type of perfection that craftsmen used to aspire to in making luxury objects has given way to another image of luxury.

Contemporary luxury depends on finding new things to do that are difficult. It can be using more of a material than is strictly necessary. It can be concealing the stitches on a suit, or the welds in a car body where one panel meets another. It is easier to carve a curve in wood than to form one in the metal body panels of a car. Before the newest technologies made complex forms easy to make on the production line, luxury cars came with curves that were difficult to form in metal, and cheaper models tended to have boxier silhouettes, or sim-

pler curves: the difference between the original Citroën 2CV and the complex multiple curves of a contemporary Maserati.

If a machine can cut a piece of wood objectively more accurately than a craftsman working only with hand tools, but the craftsman's work is understood as being of higher quality, we face the paradoxical situation of machine-made artefacts having imperfections deliberately introduced to suggest quality.

There are still people who bind books, but bookbinding has turned from a practical skill into a means of self-expression. And there are those who use film rather than digital photography, or analogue recording techniques. But handcraft for its own sake has become marginalized to the point of extinction. It has been redeployed within the industrial system, where it provides the essential skills needed to make the machines which make the things we use. And it is these skills that underpin luxury in a contemporary sense. Crafts are essential to building aircraft, to making spaceships, and the entire Formula One car industry.

The heavy steel mould in which Jasper Morrison's Air Chair is made by blowing gas through molten plastic is in itself a remarkable object. To make it requires an exceptional degree of skill. And the moulding process is based on a technique developed for making parts for the car industry: the plastic panels that line the car interior, and the dashboard glove compartment, and the steering-wheel housing. Equally, the techniques of fibreglass moulding used to make certain kinds of furniture or car bodies, or boats, while they appear to remove every trace of the hand, are actually entirely dependent on the craft skills needed to lay the strands of reinforcing material. The resulting industrial products are as much a work of art as a woven textile, even though the artistry is invisible.

To make a mass-produced car requires an extraordinarily dense concentration of craft skills at every stage of the design, from the clay models that are produced by the styling studios to the exquisite wood

Jasper Morrison's Air Chair is made using blow-moulding techniques developed to produce low-cost plastic parts for car interiors.

models that were once needed to shape the bodywork. To design a car demands tens of thousands of man hours. There are people at Ford who specialize in handles, just as Rembrandt's studio was able to call on the service of specialist ruff painters and sword-renderers. And the

process is as much the creation of an emotional narrative as it is an objective matter of engineering calculation.

By any standards, Bentley, which sold 5,600 cars in the first six months of 2007 – an increase of 30 per cent on the previous year – is a luxury car maker. The cheapest car it offers, the Continental, costs £130,500: ten times the price of an average saloon. The company calculates that a customer would need disposable wealth of around £2.5m to be able to afford one. Then there is the Arnage, at a price that is hard to pin down because of all the optional extras that the company offers to give the impression of making made-to-measure cars, for those with a net worth of £10m.

The new Bentley range was one of the success stories of the economic boom of the first decade of the new century. The Bentley name is associated with a quintessentially British version of motoring, but it has been acquired by an even more quintessentially German company, Volkswagen.

When Volkswagen took over Bentley, the company set out to build a car that lived up to and would reflect the connotations of a marque that seemed to suggest British engineering tradition and an association with what was once described as snobbery with violence – no small task for an enterprise originally established to build the people's car for Adolf Hitler. It kept the flying-B badge and the chromed-wire-mesh radiator grille, but everything else was new – including the specially built factory and the design team, with a Brazilian head of exterior styling whose last project had been with VW's Czech subsidiary, Skoda.

The means by which the new ownership managed to build a series of new models that appeared to be the inheritors of all the virtues of the Bentley name is a triumph of manipulative brilliance. Not the least achievement is their success in overcoming the essential technical dilemma for a luxury product made in tiny numbers and sold for very high prices in an age of mass production.

The basic problem for any luxury car maker is the cost equation. Selling low-cost cars is based on the economics of mass production. It demands a huge investment in machine tools and moulds, to shape every part, so equally huge numbers of cars have to be sold to recoup the investment. All that tooling allows for a remarkable concentration of effort on producing complex curved shapes. It means that the car can have unique designs not just for all the most visible components, but for the hidden details too. A high-price luxury car has exactly the opposite economics, based on building cars in their thousands, even their hundreds, not their millions. The total production of the Ferrari California Spyder was 104. That means that far less tooling investment is possible. The tools that can be funded do not allow the level of sophistication that mass-produced cars can afford. But they can be used to create an impressive silhouette, especially when manipulated by skilled craftsmen.

The difficulties are more serious when the designers start to explore what they can do in the way of a door handle, a rear-view mirror or a stop light, or even a key-and-lock system. The toggles and switches used for many luxury brands will often be relatively crude off-the-shelf components, shared with lesser breeds. Making a switch by hand is not an option.

This is a phenomenon that produces a curious inversion in values and visual clues. The most expensive cars can sometimes have the crudest, most basic components. Bentley's solution with the Continental was to develop forms that made the most of its strengths in panelbeating. They make possible a distinctive body with the personality of a Bentley. The introduction of milled metal, shaped by cutting rather than by pressing into a mould, changes the equation again.

The result is a car which suggests that it might belong to the past, without actually looking old. The car has a high waistline, which gives it the look of a sweeping motor launch. It also gives the driver the alti-

tude to be continually looking down on the surrounding world. There is a convincing impression of solidity, and mass. The side panels have a reverse curve as they flick up over the air intake that is built into the front bumper, giving the car a characteristic massive quality.

Slightly less convincing, the headlamp housings on each side of the grille are bisected by a black junction line where upper and lower panels meet. Smaller cars with vastly longer production runs can handle this junction differently, creating the illusion that the body is a

Bentley is a brand owned by Germans, with a Brazilian head of exterior styling, but both its Continental and Arnage models attempt to project a certain kind of Englishness. The difference is that one costs rather more than the other.

seamless bubble. Other cars make a virtue of it, like the original Mini, which had the body sides and front panels coming together in a metal flange standing an inch proud of the body.

The idea of attention to detail is an integral part of luxury. But when cars perform equally well at either end of the price spectrum the unintended consequence is that the key aspect in making the difference for a £250,000 car can be the £50 needed to make the driver's iPod compatible with the car's entertainment system. Amid all the work that has gone on in wind tunnels testing aerodynamic forms, on the fuel efficiency of the engine, and on the lightening of the structure while retaining the car's road-holding and crash-survival characteristics, the music system may seem little more than trivial. But it is the details that create the sense of luxury.

When Veblen wrote his book, handcraftsmanship was still accorded the highest status. Since then, we have become accustomed to the universal presence of technology, and what it can offer. Our visual perceptions of what constitutes quality have shifted accordingly.

The dilemma was made clear during the craft revival of the 1970s, when the imagery that inspired craftsmen in wood was derived from the machine. Makers such as John Makepeace with his school teaching craftsmen in wood at Parnham – perhaps the last organized incarnation of the Arts and Crafts tradition in England – produced pieces clearly inspired by contemporary furniture designs that were dependent on injection-moulded plastic; the result was to torture wood into forms that were alien to it.

The counter-intuitive truth is that simplicity is expensive. It is almost always more costly or more demanding than elaboration, and superfluous complexity.

Simple geometric forms are much less forgiving to the maker, because they leave no margin for error. A skirting board, positioned at the foot of a wall where it meets the floor, is the most convenient way

to hide the junction between plaster and concrete. It removes the skill that is needed to make it a perfectly straight junction line. You just hide it. And, once having applied a skirting board, you might as well make something of it by embellishing it with a complex profile. If you are an architect like John Pawson, however, you don't do any of those things: you leave a shadow gap between the floor and the wall, suggesting the intersection of two planes each stretching to infinity. It's aesthetically elegant, but very hard to do. It suggests understatement, but, paradoxically, it can mean the exact opposite, demanding huge effort to realize it and amounting to a kind of baroque minimalism. It has also come to be seen as the language of contemporary domestic luxury – a world where you can grasp the infinite variety of shades of white as the sun, filtered through a waxed cotton blind, moves across a wall on which there are no pictures or shelves, a floor on which there is no carpet, a door which has no handle. In Veblen's terms, it is only those who are secure in their affluence who feel comfortable to live without making a show of their possessions.

A life of luxury implies a life without physical labour. But a luxurious object is not necessarily an undemanding one. It's not just in the making that effort may be required, but also in maintenance. Polishing silver and brass and copper, maintaining leather, and scrubbing stone were once at the centre of domestic life.

Luxurious fabrics are those most closely associated with high maintenance. A linen sheet needs to be laundered and ironed every time it is used. A shirt that is made of a fabric that does not need ironing bears a stigma. It cannot be truly luxurious if it is too easy to maintain, despite the best efforts of makers in the expanding market for high-performance clothes that use water repellent lightweight crumple-proof textiles.

Understatement is a recurring theme of what is described as aristocratic luxury. It is the embodiment of the idea that it is bad man-

ners to make your own wealth so conspicuous that it is constantly on show, reminding those who are less wealthy just how much more you own than they do. To those who understand what they are looking at, the adoption of an impeccably tailored plain exterior provides all the signals needed to indicate the resources necessary to achieve it. Self-restraint might also be understood as enlightened self-interest. During the Red Brigade years in the 1970s, the Italian bourgeoisie gave up jewellery and took to driving themselves around Milan in well-lived-in Fiats, for fear of attracting the attention of kidnappers. Dressing down of course quickly became part of the trappings of a certain way of life, just as less affluent adolescent Italians carried their car radios around with them like handbags, partly to stop them being stolen, but partly also to demonstrate that they had a car worth stealing from. Sheer abundance has left affluent consumers sated. So the signs of luxury are manipulated to trigger the gratification that it brings, without the substance. It's like bypassing the physical senses and going straight to the brain to fire up the neural networks that make us feel hungry or tired or contented or angry. Or, in the case of luxury, soothed and reassured. It is an addiction of a kind.

Luxury is partly created by the use of materials associated with it. The precious and the rare are generally the most sought after. So plastic, which is neither, has had trouble being accepted as a noble material. But so too has titanium. The metal has never become the modern version of gold that the titanium-mining industry hoped it would be.

The visual and tactile signs of luxury are closely associated with value. They are the triggers that make us believe that one object is worth more than another with the same functional characteristics. Luxury can be signalled by audible cues: the sound of a car engine, or of a solidly built door closing, or the click of a catch fastening into place. Or the message can be conveyed by signs that suggest performance. Try as we might, we cannot help but interpret an air-intake grille

on the side of a well-chiselled car bonnet other than as adding to the car's value. The more that an object could do was once understood as having a direct correlation with its efficiency. The profusion of dials and gauges on electronic equipment of a certain age was a reflection of the need to inform owners just how much their machine was capable of, even if the information conveyed by all those beautifully precise dancing needles was of little practical relevance to the owner.

Packaging is an inevitable prelude to our experience of an object. A wristwatch comes in a tin container inside a box inside a bag made from glossy coated five-colour printed paper with rope handles, even though all of these layers are immediately discarded. A pair of expensive socks comes with a strip of tissue paper slipped inside one of them, providing a three-second never-to-be-repeated rustle the first time that you put them on.

Manipulative luxury is not limited to the objects that we use, or the packaging that they come swaddled in. It is also used to shape the choreography of everyday activities. This is nowhere clearer than in the manufacture of a sense of luxury in air travel.

If you look at the floor plan of the business-class cabin of a Virgin Atlantic Airbus A330, you will see a herringbone pattern that irresistibly suggests the hold of an eighteenth-century slave ship. In fact it shows the rows of seats in which the would-be financial masters of the universe are prepared to sleep – their heads inches away from a snoring, flatulent stranger – secure in the belief that they are travelling in luxury. Conditions are of course even more squalid at the back of the plane, which helps those at the front swallow far higher prices. Business-class passengers are issued – free of charge at the point of delivery, as they say of the National Health Service – with an Anya Hindmarch amenities bag. They get vintage champagne, and the half lemons that accompany the smoked-salmon hors d'œuvre are encased in muslin, to avoid the hazard of low-flying pips. But of course any-

body who really worries about this sort of thing would never want to be seen travelling on a commercial flight. The private jet is entry-level luxury travel for a certain class now. Yet even this, at its most basic, offers conditions not dissimilar to those of a caravan – with crew and passengers sharing a lavatory behind a curtain – even if it avoids the cattle pens that passengers attempting to board a low-cost carrier must endure.

Luxury in our times revolves more and more about the details that persuade consumers to spend money. But another definition of luxury – one that is closer to its original meaning – may prove increasingly pertinent. It sees luxury as the way to provide a sense of respite from the relentless tide of possessions that threatens to overwhelm us.

4 | FASHION

A CONTEMPORARY FASHION SHOW IN MILAN, Paris, New York or London is a place where public life of a special kind is conducted. Indian steel billionaires encounter the ex-wives of Russian plutocrats. Lilly Allen and Gwyneth Paltrow mix with Rem Koolhaas and Anna Wintour. Footballers and rappers share a brief, vivid explosion of publicity. As in a nineteenth-century opera house, celebrity goes on show and status is measured in an agonizingly exposed way. For those in the social Siberia of the back row, their lack can be found in the humiliating and intricate hierarchy of the seating plan. The front row is allocated through a process of negotiation in as much deadly earnest as anything seen at the UN Security Council.

Unlike an opera, however, a fashion show need

last no longer than 20 minutes, and there is no second act. Its brevity makes it the perfect cultural form for the severely limited attention spans of the post-print generation.

The phenomenon of the fashion show as spectacle has gathered pace since haute couture came back from the dead in the 1980s. A ritual that began in the nineteenth century for a few select customers in the salon of the House of Worth in the rue de la Paix in Paris, over tea and delicately cut sandwiches, has spilled out from Worth's competitors – venerable fashion houses in the *huitième* – into the tents, old vegetable markets and redundant railway stations in which designers now compete to stage the most lavish spectacle.

The fashion show has moved on from being a means to an end to become an end in itself – one that has little to do with the mundane process of giving buyers a look at the new season's clothes and taking orders. It has been turned into an event whose primary purpose is burnishing the brand. Even more important than the act of showing off a collection is the chance of showing off, in front of the world's cameras, an audience of celebrities looking at the collection.

And now the most ambitious fashion houses are building permanent arenas in which to do it. Dolce and Gabbana have taken over a cinema as a base. With the Japanese architect Tadao Ando, Giorgio Armani has built what he calls a theatre in an old chocolate factory in Milan. Its layout is an update of the traditional opera house, with its grand staircase, designed to build anticipation on the way to a tightly packed auditorium. The transition from the messy industrial suburbs of Milan outside to the world of Armani inside is marked by a stately march of austere concrete columns like a monastery cloister. Reception desks in the form of immaculately precise glass boxes, glowing with light like Dan Flavin sculptures, could pass for art.

The action on the stage, with its chorus of international fashion editors and photographers, is only one aspect of the performance.

Giorgio Armani shows his collections in Milan in a specially built theatre designed for him by Tadao Ando, with the scale and ceremony of a particularly severe opera house.

Ando's architecture is designed to make the most of the celebrity audience, with a long, photogenic promenade before they reach their seats through giant doors into the theatre. It's a two-way transaction, in which both sides need each other. The stars are endorsing the event with their presence. And, provided that Armani manages to keep his hold on the media and maintain the credibility of his name, the rising generation of stars feel the need to be at the shows. It's their status that is being lifted as much as Armani's, and free use of the clothes certainly doesn't hurt.

The models do their show on the runway; the audience performs on the way in. And for the after-show party there is a severe, heroically proportioned dining room in which to sip champagne. Its low windows are carefully positioned to frame the reflecting pool outside. Whatever the clothes themselves are like, the audience leaves in no doubt that it has seen something that matters.

Designers who have built successful businesses based on fashion have to learn how to deal with the need to be constantly looking for a newer, younger audience without alienating their older customers. It's a delicate balance. They have to keep enough of what made them attractive in the first place. But it's only by introducing things that are new and different that they will avoid growing old with their original clientele. The most difficult thing to get right is when to move from updating to starting again.

It was a particular problem for high fashion in the 1960s. Despite Yves Saint Laurent's creative genius, for the post-1968 generation couture fashion was a snobbish anachronism, identified with the wrinkled and the culturally irrelevant. It took a new generation of ready-to-wear designers, Armani in Europe, Ralph Lauren in America, who had started their careers in mass-market retailing, to resurrect the old rituals. Much as the House of Windsor has also had to change the nature of its garden parties, investitures and protocols with a judicious

injection of celebrity and populism, so fashion started to take on new audiences and learn new tricks with which to entertain them.

To maintain its relevance to the wider world and its grip on public attention, fashion has continually had to charm new elites, not only as potential customers, but also for their appeal to a media audience. The original couture customers of the nineteenth century have been supplemented by successive waves of new money, and new forms of celebrity. In the last 25 years fashion's new customers have come from the Arabian Gulf, and most recently from Russia.

In 1980 Giorgio Armani realized the promotional potential of cinema for his business, then just five years old. When Richard Gere starred in *American Gigolo*, Armani dressed him from head to foot in beige. It was a role that taught heterosexual American men how to dress: Gere lingers in front of his mirror, running through a selection of unstructured Armani jackets, matching them with ties and shirts.

Armani was the latest in a long line of fashion designers who had worked in the cinema. Hubert de Givenchy had designed Audrey Hepburn's outfit in *Funny Face*, in which her character models couture. Hardy Amies gave Kubrick's *2001: A Space Odyssey* a restrained futurist look, and Yves Saint Laurent dressed Catherine Deneuve in *Belle de Jour*. But it was Armani and Ralph Lauren – who dressed almost the entire cast of *The Great Gatsby*, and later created Woody Allen and Diane Keaton's outfits in *Annie Hall* – who used film in the most effective way. *American Gigolo* and *Gatsby* were both dealing with deeply flawed characters, but the films nevertheless managed to popularize the way that their protagonists dressed. They also did a lot to establish the glamour of the Armani and Lauren names. Both designers were to some extent depending on their own memories of film for their collections. It was a curiously mirror-like process: cinema was shaping fashion shaping cinema.

Armani did all he could to blur the boundary between cinema and

He's the highest paid lover in Beverly Hills.

He leaves women feeling more alive than they've ever felt before.

Except one.

American Gigolo

Paramount Pictures Presents A Freddie Fields Production A Film by Paul Schrader Richard Gere in "American Gigolo" Lauren Hutton Executive Producer Freddie Fields Produced by Jerry Bruckheimer Music Composed by Giorgio Moroder Written and Directed by Paul Schrader [Original Soundtrack Recording on Polydor Records and Tapes] A Paramount Picture

While the cinema of the past has provided many of the references for contemporary fashion, more recent films, from *Annie Hall*, which Ralph Lauren helped style, to *American Gigolo*, for which Giorgio Armani designed Richard Gere's wardrobe, have given designers a highly visible platform.

reality. He ensured that 'his' stars had front-row seats at his shows, that they got married in his outfits, and that they spent time on his yacht and in his villas.

Cinema stars were followed by the music industry. Ageing musicians decided to look beyond the counter-culture. Eric Clapton suddenly started dressing in Giorgio Armani black-label suits. Then it was football stars, and most recently it has been the newly affluent generation of contemporary artists.

As with so much else, co-opting culture into fashion was a move led by the Japanese. Rei Kawakubo of Commes des Garçons was using Francesco Clemente, Robert Rauschenberg and Leo Castelli as models for her clothes in the 1980s. And she was also one of the first designers to use men and women with lived-in, battered faces to show her work. She was suggesting that there could be a more cerebral aspect to fashion, beyond simple hedonism or a means of demonstrating wealth.

As fashion has evolved from a craft into an industry, it has fuelled the growth of large-scale luxury-goods conglomerates that cover clothes, fragrances, luggage, watches and now furniture too. It's a process that generates a relentless hunger for creative input. Fashion must continually look for fresh ways to engage and to make a mark. It has become voraciously demanding of new material to provide an uninterrupted supply of the visual allusions on which every collection is based. The design studios for the big names have to deal with intricately overlapping sets of subsidiary brands that each fashion house maintains in order to address the key price points from mass market to stratospherically costly. Overlap too much and the customer becomes confused, one label starts to cannibalize another, and the brand as a whole is diluted.

The extent of the insatiable hunger for ideas and images – the raw material of fashion – becomes immediately apparent when flipping

through an issue of Italian *Vogue*. The monthly magazine regularly expands to more than 800 pages to reveal the distilled energy of a fashion season. An issue of *Vogue* coinciding with the collections is crammed with advertising whose sole purpose is to differentiate one fashion brand from another in the fraction of a second that it takes to turn the page. There is no time for words or, often, even to show the clothes. Fashion is reduced to a relentless and endless series of head-spinning images that can, however briefly, grab a jaded audience by the jugular.

Sex is the single most obvious recurring theme. At one time or another, almost every Italian label has gone in for lovingly detailed evocations of seventies pornography in its advertising. And so have many of the French and the Americans. Some have carefully styled their models to look like hookers from the 1940s. Chanel even had one of its outfits photographed outdoors in a darkened street, caught in the headlamps of a passing car, in a style suggestive of the prostitutes who frequent the Bois de Boulogne on the lookout for kerb-crawlers.

Fashion, despite turning into an industrial juggernaut dominated by three or four conglomerates, depends on art, photography and film for its visual references. It uses those images so relentlessly, to feed four collections a year, that their themes are quickly stripped of meaning. Inevitably, the process of offering a constant diet of spectacle is subject to the law of diminishing returns. One Helmut Newton or Robert Mapplethorpe image reproduced, or copied, in a fashion magazine and you pay attention. A whole magazine-full and you start to glaze over, and the original image is itself diminished. Pictures that would once have been arresting, very quickly lose their power to engage.

Fashion is not art. But there has never been a time when fashion has done more to suggest that it might be. The Guggenheim Museum

While the Japanese relied on art, Gucci and Calvin Klein were ready to fall back on sex, an old standby, even with the addition of a layer of irony that comes from parodying the style of soft-core pornography.

took Armani's money to stage an exhibition of his work in the Frank Lloyd Wright spiral of its Fifth Avenue building. When he was Gucci's creative director, Tom Ford financed Richard Serra's rusting steel spirals at the Venice Biennale. And Andreas Gursky photographed Prada collections with the same eye for discovering the monumental in unlikely places that he brought to the Shanghai stock exchange. Fashion is looking for a blood transfusion from the energy of contemporary art.

And the fashion monster, not satisfied with getting its claws into art and architecture, has taken another deep gulp and swallowed design whole. The Art Basel/Miami circus brings together the very rich, the fashion-conscious, and the art and design worlds in one head-splitting mix every December. It's not exactly that design was an innocent victim. Furniture designers have been hanging about there for ages, hoping to get noticed. They have always hankered after a bit of stardom. But when design finally turned into fashion it turned out to be not nearly as much fun as they had been hoping, and they remembered, a little guiltily, that design should be about serious, technical things, not shallow styling. It should be about turbo-fan jet engines and whole-body scanners, not frocks, hats and trainers. It should not be about the fleetingly fashionable.

The question to ask is not so much Is fashion really design? but What has fashion done to design? And, for that matter, What has it done to art and photography and architecture?

For most of the last century, architects and designers, though fascinated, were dismissive of fashion. Le Corbusier once put the sense of barely concealed antagonism into words when he suggested that style for architecture was of no more significance than the feathers on a woman's hat: pretty enough, but of no real importance. Fashion, according to the puritanical, is what used to be called a minor art. But for better or worse there is nothing minor

about fashion, which mainlines on sex, status and celebrity. And it is that combination that has conferred a huge amount of clout, both financial and cultural, on those who control it. Put all this together, and it's not surprising that fashion has become just too big and too powerful to be written off as a frivolous sideshow. Fashion has the ability to press all the buttons of contemporary life. It represents a convergence between high culture and popular art that gives it real power. It can address serious issues, but it has also got a grasp of the popular imagination in a way that design more narrowly drawn has reason to envy.

But fashion has mostly been considered in curiously unreflective terms. Adolf Loos was one of the few exceptions. He found fashion to be of abiding interest, and wrote about the restraint of British tailoring as the perfect expression of modernity. Slyly, he explored the mechanisms by which fashion was created, and he thought long and hard about why it was that the Germans agonized over the width of their trousers. The answer, he believed, lay in German self-conscious aestheticism. 'The English and the Americans expect everybody to be

Miuccia Prada collects art and funds an important Milanese gallery. Having Andreas Gursky photograph her products is somewhere between culture and commerce.

well dressed. But the Germans go one better, they want their trousers to be beautiful as well,' wrote Loos in 1908.

> If the English wear wide trousers, the Germans immediately prove, using old pictures or the Golden Mean, or something like that, they are against the laws of aesthetics, and that only narrow trousers conform to the canon of beauty. They curse and they swear but each year, they make their trousers a little wider, complaining that fashion is a tyrant. But what is this? Has a Nietzschean reassessment of values taken place? The English are already wearing narrow trousers again, and precisely the same arguments are used about the aesthetics of the shape of trouser legs, only the other way around.

Loos was already aware of the continual oscillation that characterizes the nature of fashion. He was also definite about the nature of modern dress. 'The point is to be dressed in such a manner as to attract as little attention as possible. A red tailcoat would attract atten-

tion in the ballroom, therefore a red tailcoat is not the modern style for the ballroom.'

This was part of Loos's onslaught on the cult of the dandy, and belongs to the days before fashion had become industrialized. There is a refreshing astringency to such views. But Loos was one of the first architects to design a fashion store. He created Goldman & Salatsch's Vienna emporium. It had the kind of restraint that characterized Loos's approach to clothes, relying on fine materials and careful workmanship rather than applied decoration. It was the forerunner of the current wave of fashion stores that serve to establish the character of a brand with a theatrical distillation. They are used not just to provide a platform that can make clothes look good, but also to convey the essence of the label's values, and to show how they can be extended to a range of objects that can bask in the reflected glory of a celebrated name.

Whatever else they might try to do, fashion flagships work hard to

The tradition of using distinguished architects to build high-profile fashion stores can be traced back at least to Adolf Loos and his men's outfitters in Vienna. Miuccia Prada has been the most determined exponent of the theme today, with a collection that goes from Rem Koolhaas's outpost on Rodeo Drive to Herzog and de Meuron's crystalline tower in Tokyo.

suggest a particular way to understand the clothes that they sell. The signals can be straightforward. Space equals money. Place a single object every 10 square metres, each one carefully washed in the soft light of an individual spotlamp, in a shop with a floor of Portuguese limestone the texture of cashmere, and you are conveying (with a fair degree of precision) a message about the nature of what you are selling. Pack fifty things on a rough-sawn wooden pallet crammed on to 1 square metre of linoleum and it's quite another message, and a different price point. What is less clear is whether the limestone, the lighting and the space actually are money, or only a symbolic representation of it.

Miuccia Prada uses the language of design in a more sophisticated way than many of her competitors. They have not caught up with the world: they build clothes shops that look like art galleries used to 20 years ago. She makes them the way that art looks now.

Rem Koolhaas, who designed her Los Angeles store, takes a vis-

ceral delight in deliberately setting out to do exactly the opposite of what everyone else is doing. On Rodeo Drive, gold leaf, granite and travertine are all but obligatory. So Koolhaas uses rough foam, polycarbonate and industrial aluminium to line the interior of a shop on the most expensive street in the world. Everybody else has ostentatious security, but during business hours Prada is entirely open to the street, with no shop window and no door either – just air conditioning and an aluminium barrier that is lowered out of the way every morning. There is a window display, but the mannequins are buried underground, visible only through two portholes set flush with the pavement. It's an intellectually ambitious – some might say pretentious – meditation on the nature of contemporary fashion.

Koolhaas's obsession with collecting data is reflected in the figures papered over the walls of the VIP suite, which allow Brad Pitt (should he be in the mood) to reflect on the percentage of Americans over 65 living in care homes when he comes in to change a shirt. Overlying everything is an attempt to create an aesthetic that celebrates artificiality. Certainly it is provocative, but in the end it's still not much more than an attempt to make Prada stand out from the competition in order to sell more suits for more money – albeit an attempt based on analysing the signals conventionally used to suggest fashion, and reversing them.

To make a fashion flagship in Tokyo, it is no longer enough to create a shop interior, no matter how exquisite. To stand out in this shifting seascape of an environment, you need to build something on the scale of a supertanker, or even an artificial island. Herzog and de Meuron's six-level Tokyo store for Prada is exactly that. It created a new building type: part billboard, part architectural gift wrapping. It's a landmark that holds its own in the context, but also makes its own context. The architects have piled most of the store into a little five-sided tower with a pointed top that stands close to one corner of

the site, leaving the rest open as a public plaza. Given the cost of land in this city, it is a generous, even profligate, gesture.

The tower has a tail, a ribbon wall that unwinds around the edge of the site, protecting it from its neighbours, but without being hostile to them. It bulges open at one end to provide access down a flight of steps into the basement. The finish for this tail is remarkable. A skin of living green moss sprouts through square blocks to create a vaguely Aztec pattern. This gives a clue to what the building, with its multi-layered references to natural materials and organic forms, is about. Its material qualities, which range from rough to smooth and tight to loose, give the building its distinctive character.

The tower has four different types of glass: some flat and transparent; others, in the changing rooms, etched for modesty. Some windows push outward, while others are sucked in, as if the building were breathing. The same themes shape the interior. The ceilings are perforated metal, into which a series of larger black holes has been inserted, drawing the surface smoothly inward to make way for the lights. In the corridors, the lights go the other way, marked by dollops of silicon gel bubbling outward.

If the exterior is wet and mossy, the interior demonstrates an almost perverse interest in mixing hairy surfaces with viscous finishes. Some display racks are sheathed in pony skin, others are coated in silicon. There are display tables in moulded see-through fibreglass, and some are filled with fibre optics like jellyfish tentacles.

In the basement, the floor is the same raw oak that Herzog and de Meuron used for Tate Modern. But on the upper levels the floors vary between lacquered steel for stairs and a vulnerable ivory-coloured carpet that even the infinitely careful and patient Japanese have trouble keeping spotless.

Fashion, like art and like design, can be understood as a form of alchemy. Art is extraordinarily effective at making the base metal of

canvas, fibreglass, shark meat or videotape, into the raw material of the auction room. Fashion does something very like this, but on an industrial scale, with cotton and polyester, silk and wool. And making fashion or wearing it directly touches almost everybody. Fashion reflects the nature of self-defined groups or individuals, and their shared morality and faith. But it has also been the driving force behind industrialization.

Fashion has gone with remarkable speed from a craft to an industry. The drive to increase production in innovative ways encouraged textile makers in eighteenth-century England to create the spinning jenny and the steam-powered looms that changed the shape of the world's economy. In India two centuries later, the same impulse made the fortunes of the mill owners of Ahmadabad. Like the cotton kings of Manchester before them, they were progressive enough to invest in education and culture. They commissioned Le Corbusier to build their houses, and offices, and Louis Kahn to design a business school. In the 1950s, they went on to ask Charles Eames to draw up a curriculum to train their designers.

In Italy, the nature of contemporary fashion was transformed by the Benetton family, with their investment in production, distribution and design for the mass market, just as much as by Armani or Versace. They used new techniques to supply their shops with fresh product in a matter of days and to restock with successful lines on a just-in-time basis, rather than relying on the old system and risking everything on a production run for a whole season.

In more recent times, it is the factories of Bangladesh, Sri Lanka, China, Mauritius, Indonesia and Mexico that feed the appetite of Western markets for the clothes that are the basis of the fashion system. At the same time they transform their own societies, creating entry-level jobs, most of them for women, some for children.

Fashion turns shirts sewn together for pennies in Indonesia into

high-margin goods. Sri Lankan factories pay minimal wages to garment workers who use their skills not just to make denim into jeans: they labour longer and even harder to artificially distress those clothes. After they have made a functional garment, they carefully unmake it again to give it the gloss of fashion, which is what accounts for most of its value.

Maybe the mark-up for fashion doesn't match the scale of the appreciation that art offers a dealer or a shrewd collector, but fashion does operate on an unimaginably larger scale. It drives the sweatshops of Asia and Latin America, as well as the ateliers of French haute couture, the craftsmen of Italy, and the high-tech factories of Europe.

The fashion system depends on ingenuity of every kind: the techniques of mass production, the making and colouring of cloth, distribution on just-in-time principles, the creativity of designers, and the skill with which their work is used to create the aura that gives clothes their appeal. It demands the creation of an appropriate platform to present the clothes, and an understanding of psychology. But fashion is still treated as if it were essentially frivolous. In part this is because of the deliberately cultivated theatricality of the most visible aspects of the system. Yet fashion employs millions of people around the world, ranging from highly skilled pattern-makers and seamstresses, to piece workers, to the image manipulators who shape fashion advertising campaigns. Branding and celebrity have ensured that only the names of a handful of them are ever recognized: the celebrity designers, many of them employees of the corporations who own their names, the supermodels, the stylists and editors and photographers.

With the rich and the glamorous, these constitute a magic circle that provides and consumes the imagery that drives the system. But the process of influence works not just in one direction. Fashion is also a democratic form of expression that anybody is able to use,

and consumer's choices shape the way that the magic circle operates, sometimes driving it in new directions and providing it with its raw material. Sometimes the audience takes command of what the system is offering and puts it to work in its own way.

Fashion represents the line between belonging and not belonging, and signs of the two states regularly reverse. The tattoo moves from being the mark of the semi-criminal to the ankle of the spouse of the Conservative Party's candidate for prime minister. Ultra-low-slung trousers move from prison wear, enforced when convicts have their belts removed, to mass-market youth cult.

In *The Interpretation of Dreams*, Freud suggests that people who habitually wear military uniforms get the same kind of anxiety dreams about appearing in public in civilian dress that the rest of us get about public nudity. But the boundary between what we call fashion and what we call uniform – apparently between the frivolous and the serious, the fragile and the durable, the contrived and the authentic – is not clear cut.

If fashion is about defining those who belong and those who don't – and it certainly is used to do that – then so is a uniform. Fashion serves to define groups that see themselves rather differently from armies. But uniforms, just like fashion, are designed to confer prestige. A uniform is intended to make those who wear it feel good about themselves. Military uniform is apparently inherently endowed with the quality of authenticity that fashion puts a premium on. Yet uniforms are far from the innocent creations that their owner's would want you to take them for.

Camouflage is ostensibly a functional, practical phenomenon, adopted by the armed forces of every country for the purposes of concealment. But over the years it has in fact been transformed into a pattern for differentiation. Every national army has its own camouflage pattern, and uses it to tell friend from foe. At the same time that cam-

ouflage tries to make its wearers invisible, it is also generating a highly visible signal, intended to identify them to their own side.

Uniforms are simultaneously about command and control. They are about belonging and not belonging, about turning an individual into a member of a group, and about defining that group in opposition to others. These are all aspects of the role of fashion in civilian dress. Ever since the development of khaki and camouflage, the military uniform has always looked for an alibi in function. But uniforms depend on symbolic meaning expressed through colours, accessories and badges of rank. They use Velcro instead of buttons, and big trouser pockets for carrying things. And these elements are not just functional. They are there to signal that the wearer means business.

The most fundamental purpose of a uniform is to make its wearer look as intimidating as possible. This can be about emphasizing masculinity or, given the current military gender balance, of de-emphasizing sexuality. In the days when physical strength was critical, uniforms were designed to make wearers look bigger than they really were. The plumes on a classical Greek helmet, or a grenadier's shako, can still impress.

A military uniform is also designed to deal with highly specific contexts: the mess, the drill hall, the parade ground, and the battlefield in summer and winter, in desert and snow. And it offers opportunities for the wearer to customize it with their own marks through badges of rank and military decorations. The uniform highlights the paradox between fashion as a means of individual self-expression and as a way to suppress individuality and provide a prefabricated identity for those who wear it.

Army uniforms have roots that are far closer to civilian fashion than is now generally understood. In the days before conscription, officers had their uniforms cut for them by the same tailors who would have made their civilian suits. Uniforms are as much self-conscious

Military camouflage is based on a glaring paradox: it is meant to make the wearer as invisible as possible, and yet every army in the world has camouflage patterns that are distinctively their own to tell friend from foe. Clockwise from top left: German, American, British and Syrian.

creations as any fashion collection. And uniforms also react to the swings of mood that drive fashion, as seen in the tendency for armies to adopt the clothes of the most recently victorious powers. The Napoleonic style once set the tone for all the minor European powers. After Prussia's military victories, the spiked helmet and field grey became far more popular than the kepi.

Like the cinema, uniforms are both shaped by fashion and help to shape it. I remember when I walked into Yohji Yamamoto's studio in Tokyo there was no sign of anything that he had designed himself. But he had hung a rack with a US Army parka, a military tunic from the Japanese self-defence force, and what looked like a foul-weather coat from the fire service. They were there for research purposes, to provide a few clues on the seams and the epaulettes and the buttons for a collection that he was working on.

Giorgio Armani, on the other hand, was commissioned to redesign the uniforms of Italy's paramilitary police, the Carabinieri. The first Carabinieri uniform, in 1814, took its inspiration from the recently victorious Napoleonic army. Now it's American special forces that provide the visual cues, but big hats are still important.

The Carabinieri in riot order replace their traditional uniforms, complete with a shoulder belt, in favour of a much less formal outfit. It's a development that reflects the way that the notion of civilian formal wear has also changed. The casual clothing of one generation is the formal wear of the next.

Art is a way of looking at the world. But so is fashion. It can be the most intimate, the most personal, and the most powerful way to communicate everything from military rank to sexual orientation and professional status. It can be democratic or snobbish, creatively nuanced or blatantly sexualized.

It is these multiple messages that make fashion such a potent force – one that so many regimes have attempted to control by using elabo-

When Giorgio Armani was asked to redesign the uniforms of Italy's Carabinieri, it sounded at first like a frivolous aberration, but of course military uniforms have always been expected to make their wearers feel better about themselves.

rate sumptuary laws that through the ages have restricted the wearing of certain colours and fabrics to the privileged. The Romans limited the use of Tyrian purple dye, to avoid social tension; the French in the Middle Ages restricted velvet to princes: they were attempting to enforce a social hierarchy, and to repress the pretensions of newcomers. Such laws were a recognition of the potency of fashion as a sign of status.

This status is not limited only to the individual: it can also be a question of national prestige that is reflected by dress. From the nineteenth century, Western dress was an international cultural norm. Wearing it became the price of admission for local elites everywhere into the modern world as defined by metropolitan Europe and America. For Iranians to do without ties and to leave their collars open on CNN is a modest but visible assertion of national identity, as much as the kilt in Scotland.

Japan, which in the nineteenth century was determined to modernize itself after centuries as a hermit kingdom closed to the outside world, quickly took this on. In pursuit of its official policy of changing on the outside in order to stay the same on the inside, it imported Clyde-built steamships, a stock market inspired by the one in London, and a secondary educational system based on German gymnasia. With the institutions came appropriate Western dress. Japan's bankers and diplomats at the end of the nineteenth century were wearing silk top hats, and its schoolboys were fitted out in the Prussian-style military tunics that still survive on the Tokyo metro, if not that of Berlin.

To become modern, Tokyo had to adopt the fashions as well as the technology of the West. It took rather longer for it to achieve the creative self-confidence to take a lead in reshaping a contemporary idea of fashion.

Japan until the 1960s was regarded by Europe and America much in the same way that China is now. It was the source of a relentless

flow of low-cost, low-quality manufactured products, including the $1 blouse and endless quantities of cheap and cheerful plagiarism. The rise of Japan as a force in fashion reflects just how central a cultural role the country now has to play in the world.

The generation of fashion designers led by Issey Miyake, but which also included Yohji Yamamoto and Rei Kawakubo, who grew up in the aftermath of Japan's defeat in the Second World War, were to be a vital part of the country's transformation into an essential part of the modern world. Miyake, who had trained with Givenchy in Paris in 1968, began to explore a specifically Japanese version of what fashion could be when he went home. He mixed gangster tattoos, fishermen's fabrics and fresh, contemporary colours to create a distinctive vocabulary of his own. Rei Kawakubo's label, Commes des Garçons, took a different but equally radical approach. She was ready to deconstruct fashion, challenging conventional notions of finish and quality and preconceptions about the vocabulary of dress. When her first collections were shown outside Japan, the reaction was shock and, initially, bewilderment. The Kawakubo look was called the Bag Lady style by some fashion editors, but proved potent enough to be not so easily dismissed.

There had been plenty of interest in the exotic among European tastemakers in the past. Chinoiserie had been a powerful influence in the eighteenth century. The Napoleonic campaign in Egypt created a brief taste for Pharaonic styles of decoration. And half a century later the opening of Japan to the outside world in the middle of the nineteenth century had created a passing fad for Japanese motifs. It had a stronger impact on art than on fashion. But this importation of exotic styles was essentially a form of cultural tourism. It was not until Japanese designers arrived to show their collections in Paris and sell them at Barneys in New York in the early 1980s that the West found itself transformed into a passive consumer of the fashion of other cul-

Ataturk's image in morning dress is ever-present in Turkey. In the 1920s, his collar was the sign of his aspirations to modernity; now it's a ghostly reminder of the birth of a secular republic. Ataturk, like the Japanese Imperial family of the turn of the century, saw western dress as an essential step. As much an art director as a politician and a soldier, Ataturk abolished the fez, introduced Latin script, and built a new capital city.

tures. Before that moment, its designers had seen themselves as creating fashion, which was then exported.

Since the early 1980s, even though originally worn by only a tiny elite, Japanese fashion has had a deep psychological impact both in Japan and outside. It changed fashion from being something that Western tastemakers imposed on the rest of the world. Tokyo was now doing things that were able to change the perceptions of those who had previously believed that they themselves were the only reference point. And it wasn't just the seasonal details, it was the entire nature of what people wore. It shifted perceptions of what Japan had to offer. Fashion proved that Japan was a country that not only was technologically ingenious in building reliable and economical small cars, but also had an ability to create images and an identity that others found appealing.

What Miyake, Kawakubo and Yamamoto offered was not the reconfiguration of what might be called the folkloric or ethnic aspects of Japanese dress, though these remarkable traditions of craftsmanship and meaning certainly did provide a rich strand of inspiration. Instead, they tried to give a more cerebral aspect to clothes.

Particularly when Japanese design was available in only a few outlets, there was a mysterious, hard-to-place quality to the clothes. They used unfamiliar silhouettes, made extensive use of black, and manipulated fabric and garment construction in radical ways. This was a very different approach to gender and the body from the norms of Western fashion. It was something that was bound to appeal to those who saw themselves as independent-minded enough not to be trapped by the familiar criteria of fashion. It attracted those who understood that fashion is not always inextricably connected to youth. It was fashion, in fact, for those who do not really like fashion.

Fashion is defined both by the universe of clothes and by the phenomenon of change that it denotes. It's about the way that we dress,

Rei Kawakubo gave her label, Commes des Garçons, a French name, but she made fashion that was distinctively Japanese and for the first time challenged the notion of modernity as being a European or American monopoly.

and the messages that clothes carry. But it is also about the way that we are programmed by the world around us to look for fluctuations. The day goes through shifts in light as the sun rises and sets. The seasons move at a slower but equally predetermined pace. The idea that we expect to see our world in terms that never stay still can be seen as a natural outcome of this phenomenon, which works on multiple different cycles at the same time. Season by season, things need to look different. But on a longer-term cycle there is the differently paced shift that moves from restraint to flamboyance. It can be a response to the social climate, a reaction against economic depression or war, or in sympathy with the demographic shift towards youth of the baby boom. It takes us from overt sexuality to puritanism, from short to long, from colourful to monochrome, from nostalgia to futurism.

Our perceptions about almost everything oscillate, from intellectual fads to colour schemes, shaped by the essentially tidal nature of the way in which we understand phenomena.

We see the shift from formal to casual in this way, from the idea that the dinner jacket is casual wear for the generation that succeeded the one that would have worn tails, but formal wear for those who would prefer to wear lounge suits, which are in turn formal for those who adopt jeans and trainers as everyday wear.

In the same way there was a time when the concept of what constituted appropriate casual footwear was limited to highly polished brown-leather lace-ups. The style was identical to that of the traditional formal shoe: only the colour changed. Laces, and constant maintenance through mirror-finish polishing, were still compulsory. But that colour change alone was considered sufficient to signal that the wearer had left behind the concerns of his business life. Indeed, so radical was the step from black to brown that it was considered socially unacceptable to wear brown shoes in the City at all, especially with a formal suit.

And now the traditional shoe looks to be on the edge of extinction. At first synthetics were used to paraphrase its shape. But the eruption of the sports shoe changed that. The trainer rapidly metastasized from a specialized artefact, to be deployed only when required on the track or field, and began to usurp the role of formal footwear. In the same way that the four-wheel-drive vehicle brushed aside the traditional saloon car, this was a class signal at first. The young and the poor adopted the trainer and made it their own, even if the traditional leather shoe could often be substantially cheaper. Then the Nike marketing machine rolled into action. Partly as a result, the Western world's feet went soft – to the dismay of drill sergeants, who had to deal with recruits with feet too tender for traditional military boots.

At first the sports shoe was a supplement, not a replacement. It became the custom in the USA for smartly dressed women to go to work in a pair of running shoes, then swap them for something with heels when they went through the office door. If the trainer and the various other ever more specialized forms of footwear were rampant, the formal shoe still clung to its traditional shape, even though it was being relegated to a shrinking social enclave.

Training shoes, however, were driving the fashion system, with ever more flamboyant styling and colours. New collections were launched every three months, although the trainer remained within the original confines of the type. Then the sports shoe made a lateral leap, swooping on the formal shoe and subverting its traditional style. New Prada shoes are neither one thing nor another: they have turned into a kind of alien hybrid, certainly not a traditional shoe, but not pretending to be the kind of thing in which you can run 100 metres at the Olympics either. Instead they have taken on the palette of materials and colours of the sport shoe, to create a paraphrase of the functional style, and crossed it with the formal shoe. Trainers are meant to have

thickly patterned soles, like tractor tyres. Prada have parodied this by moulding their soles to look like lizard skin. There are no laces, but these shoes do not look like loafers. There is a differentiation between sole and shoe upper, but not in the conventional way. And the shoe has been designed to be worn with a Prada suit.

The consequences of the transformation of fashion from a craft to an industry are still gathering pace. Because of its ability to co-opt and exploit other forms of visual culture, fashion is transforming the way that art and design are understood. It is pushing our celebrity-driven society in ways which reveal constant signs of exhausting culture in its traditional sense altogether, and yet show no signs of losing their allure. Indeed, the fashion industry is now shaping almost all the others. Building cars or household appliances or computers is showing many of the same characteristics as fashion – a process that gives no sign of decelerating. Fashion is the most developed form of built-in obsolescence, the driving force behind cultural change.

ART

I T IS A CURIOUS PARADOX THAT EVEN THE MOST materialist of us tend to value what might be called the useless above the useful. Useless not in the sense of being without purpose, but without utility, or at least with not much of it. Manolo Blahnik makes shoes that are harder to walk in and a lot more expensive than a pair of plimsolls, though they might be rather more helpful as part of a courtship display. A Ferrari attracts more attention than a Volkswagen, but is hardly a practical means of urban transport. And, at a more fundamental level, while art is useless, design is useful. So Picasso is a far more central figure to the culture of the twentieth century than Le Corbusier, and *Guernica*, if it were ever to be sold, would command a far higher price than the Unité d'Habitation.

Some designs are less useful than others, and they are the ones that enjoy a higher status than the rest. There is a category of office furniture that used to be known as the executive chair, and another designated as the typist's chair. The latter is often the more complex and the more comfortable piece of equipment. Production runs are longer, justifying more costly tooling, and more care is taken about its performance. As objectively as it is ever possible to be about such things, it is a better chair. But the utilitarian connotations that a properly engineered, ergonomically designed adjustable chair carries encouraged managers to adopt the high-status signals of comfort, rather than the more egalitarian substance of the typist's chair. The picture was changed by the arrival of Herman Miller's Aeron chair, which redefined the rules of how a high-status chair should look and made it clear that ergonomics are for everyone – to the point that it has even started to make an appearance in domestic settings.

Very often, in fact, a high-status workplace is one in which the furniture is as domestic in character as possible. Look at American law firms and their weakness for Colonial Chippendale interiors, or, at the other end of the taste spectrum, the fondness of so many new media companies for table football and beanbags.

There is a similar perverse logic at work in the seating plan for a chauffeur-driven car. Every car is designed to make the driver's seat the most comfortable, the most accessible and the best equipped for all-round visibility, but here the most important occupant qualifies for a back-row seat, though not behind the driver.

Usefulness is inversely proportional to status. The more useless an object is, the more highly valued it will be. High-status utility is confined to such baroque elaborations of conspicuously redundant capacity as the wristwatch supposedly designed for use by divers, astronauts and racing drivers, where precision becomes a form of decoration or jewellery, or the grossly overspecified SUV.

The question of utility, which was explored at such length in Thorstein Veblen's *The Theory of the Leisure Class*, helps explain why it is that for the last century and a half design has been understood as a species of activity not to be considered in the same breath as art. Art, supposedly, is about a whole category of entirely different things. One activity is about the material, commercial, useful world of mass-produced objects, and the other is about a more intangible, slippery world of ideas, and the aura of the unique and the useless.

In Britain, design used to be called commercial art, to distinguish it from the real thing. When designers first began to organize professionally, in 1930, they called themselves the Society of Industrial Artists. That was when design came to be recognized in its modern sense, after a bitter divorce from craftsmanship. Mainstream commercial design now is treated as the idiot child of the branding industry. And the entire category of objects that can be considered as art is regarded by some cultural gatekeepers as superior to the category of objects that are designed precisely because of the usefulness of the latter.

It is a pervasive attitude. In the 1980s , when the Design Museum in London sounded out Alan Bowness, then director of the Tate Gallery and son-in-law of Barbara Hepworth, about the possibility of occupying part of the Tate's Millbank site, he is reported to have dismissed the idea with the remark that 'Lampshades do not thrill me.'

Yet there are good reasons to understand the design of objects at a deeper level. If you consider what it was that informed much of Marcel Duchamp's thinking, and Andy Warhol's too, there was certainly an intimate concern with many of the same issues that underpin the more reflective aspects of design. In particular, both Duchamp and Warhol explored the significance of mass production. The ready-made urinal and the multiple Mao screenprint suggest something important about our relationship with industrial objects and the impact of mass production on culture. They are, among other things, telling us about

the power that art has to make base materials into priceless objects. But that is what design is about too – not usually as a critical tool, but rather by offering a step-by-step how-to guide.

Design has always involved shaping or embellishing everyday things, to provide us with a reminder of the world beyond utility. It is intimately concerned with the emotional character of objects. Design is used to make things that are cheap to produce seem expensive. It makes products look rugged, and therefore glamorous, even when they are flimsy. Why can't it also make banal objects that look like art, even if perhaps they aren't?

Most designers have been trained to believe in their heart of hearts that design is not art. Perhaps that is why they so often try to be artists. George Nelson, for example, one of America's more cerebral industrial designers, claimed that 'the designer is in essence an artist, one whose tools differ somewhat from those of his predecessors, but an artist nonetheless.'

When New York's Museum of Modern Art first began to collect design, in the 1930s, it took a more careful view. For the museum, design and art were not the same, but by collecting design MoMA was deliberately trying to boost the status of design as a category. To do that, it believed it had to present design as if it were art.

While the propaganda surrounding the elevation of design into the cultural mainstream celebrated the virtues of mass production as a cultural force, the real impact of its embrace by the Museum of Modern Art was rather different.

When Alfred Barr opened MoMA, in 1929, he allowed in a few mass-produced objects and let them stand across the hall from Picasso and Braque. There was a rhetorical point to be made. Modernism was the art of the machine age, and the museum wanted to be seen to be as radical in its choice of subject matter as the artists it championed. But the selection criteria the museum used for inclusion were based

on how things looked, rather than what they could do. Propellers, ball bearings and machine tools, even a Cisitalia car body designed by Pininfarina and beaten out of sheet metal by hand, and, later on, a helicopter, were admitted to the snow-white interiors of the museum. But only if they pretended not to be design at all.

The price for a Swedish-designed – though carefully selected US-made – version of a chromium-plated self-aligning steel ball bearing to be placed in the same context as Fernand Léger's painting of a ball bearing was to caption it exactly as if it were a painting. There was nothing more than a blank announcement of date, media and name to distract visitors from their reverential contemplation of these sacred relics. Nothing about what this undeniably beautiful object was for, or how it was made, could be included. Indeed, in the museum's records Sven Wingquist, the engineer who founded Svenska Kullagerfab-

Duchamp made the world look at industrially produced objects as more than the anonymous outcome of the factory system. Warhol followed his examination of the impact of mechanical reproduction on visual culture. Their work was not design, but it was certainly about design.

riken, which made the ball bearing, is referred to, even today, as the object's 'artist'.

In its written texts and the display techniques that it uses for design and architecture, MoMA has always adopted the same inscrutable tone that it reserves for art. This is a not a good idea when talking about desk lamps and telephones or motorcycles and airport departure boards. Unlike Carl Andre's bricks, these are worth keeping in a museum not so much for their inherent qualities as objects as for what they represent in terms of the effort and the intelligence that have been brought to bear in their creation.

It's not the same for an art work. To describe the context in which Picasso painted *Les Demoiselles d'Avignon,* to show the pavilion that José Luis Sert designed for the Spanish Republic at the 1937 Paris World's Fair to house *Guernica,* to reproduce an image of one of the Junkers bombers that took part in the Nationalist raids on the city, or a contemporary newspaper account of the tragedy, are in themselves highly illuminating things to do. But if they share the same space as the work of art that they helped shape they are intrusions. For design, context and process are essential. We need to know how long a typewriter was in production and what it cost to make to fully understand it. We need to see the patent drawings, the advertising, the production tools and the packaging to get a sense of its significance. To know how Jackson Pollock made his drip paintings is certainly important. But it is not an essential precondition to being moved by his art.

That, of course, is why the Museum of Modern Art presents design in the way that it does. Whether consciously or not, it is doing its best to suggest that design is just as useless as art, and therefore almost as important.

Like the Chinese Communist Party, which still somehow manages to suggest that the Shenzhen Stock Exchange and the illegal status of the Shanghai migrant underclass are compatible with the

principles of Marxism–Leninism, so the museum continues to speak about the virtues of utility and mass production while enshrining the useless and the one-off.

Arthur Drexler, long-serving curator of the design and architecture collections at MoMA, refused to collect more than a handful of mechanical appliances during his tenure. He claimed that 'too often their design is determined by commercial factors, irrelevant, or even harmful to aesthetic quality'.

But Drexler did acquire the Bell 47D1 helicopter which still hangs in the museum, having moved from one new building into another. The bright-green machine, with its space-frame tail structure and its Plexiglass bubble of a cabin, is an object that Terry Riley, the former curator of architecture and design at MoMA, once referred to as 'our winged victory'. He made the remark during a discussion on the power of placement. The Louvre's *Winged Victory* is at the top of a staircase, a message about its importance clear enough to the vast majority of visitors who have never heard of Samothrace. MoMA's helicopter floats above a staircase too, though it dangles from a web of cables.

When it was designed by Arthur Young, in 1945, the 47D1 was the first commercially licensed helicopter in the USA. At that time it had a strong case to be described as the best, the most interesting and the most technologically advanced helicopter in the world. No one could describe it as any of those things today – aerospace technology changes faster than most. Even when Drexler acquired it for the museum, in 1983, the production line for it at Bell had already been dismantled for a decade. What now singles out the 47D1 above all other helicopters is that it was the first helicopter in the world to have been hung in a museum of modern art. And that is why it is where it is. It embodies the museum and its history as much as anything intrinsic it has to say about helicopters. It's both beautiful and useless.

The confrontation of the MoMA's design collection with art has

not helped George Nelson, and every other designer who works with mass production and domestic objects, in dealing with the perception that design is the embodiment of commerce, rather than culture. And that is why the recent appearance of work made by designers that aspires to be taken as art can seem like touchingly vulnerable bravado.

Design has grown up around a set of fundamental ideas. One is that design is a response to a brief. Designers are posed with a problem, and find a way to solve it. Another is that design is essentially democratic: it aspires to mass production and affordability, which can present designers with their greatest challenge. To design a good £2,000 chair is easier than designing a good £20 chair. Most of all, design really is meant to be useful. Of course the response from the designer to each of these challenges can be successful to a greater or lesser degree, but if the result is to be called design at all then it must at least try to address them.

At the Milan Design Fair in 2007, design had turned militantly useless. The Dutch designer Marcel Wanders had taken over a redundant factory to accommodate a score of misshapen ceramic objects that looked as if they were vases scaled up by Jeff Koons to the size of wardrobes. Next door was work by a group called Studio Job, who had made a set of larger than life-size bronze casts of banal everyday objects, including a bucket, a jug and a lantern. Dolce and Gabbana had handed over the runway in the converted cinema that is their permanent base to Ron Arad, who had covered it from end to end with a 50-metre-long drawing as the backdrop for a dozen exquisitely made Perspex objects that had a distant relationship to chairs. And at every installation and private view in Milan the Australian designer Marc Newson cast an invisible shadow. In his show three months earlier at the Gagosian Gallery in New York he had celebrated breaking the million dollar barrier at auction with a limited edition supposedly of shelves, each piece of which was cut from a single piece of Carrara

By the time the Museum of Modern Art acquired the Bell helicopter that is now an essential part of its permanent display, it was already technologically redundant. It was there not because it represented the latest thinking in helicopter design but because it was the first helicopter ever to have been hung in a museum of art. It had become, in the word's of MoMA curator Terry Reilly, 'our winged victory'.

marble. Newson's Voronoi shelves take a functional object as a starting point, but turn it into a precious work of decorative art that will stand a better chance of lasting a lifetime than, say, a car or a computer.

The designers who attracted attention at the fair were all doing things that, on the face of it, are everything that design is not. They were creating objects that had nothing to do with solving any kind of problem. They were producing things that were fundamentally useless, in tiny numbers, and at huge prices. Had they then stopped being designers? Or were they designers who had shifted the meaning of design in response to the ever more ephemeral nature of mass-produced objects? Or had they signed up with greedy dealers for a fast profit that would damage their careers in the long run?

Their work looked a lot like design in the sense that it might have been understood by a sixteenth-century *condottiere* commissioning a Milanese workshop to produce a suit of armour chased with finely worked gold, decorated with elaborate scrolls and curves, and never intended to be worn in anger.

Perhaps the divide between art and design is not as sharp as is sometimes suggested. Whether it was acknowleged or not, design has always been about more than immediate utility. And this other aspect has come closer to the surface again since Ettore Sottsass's creation of the Memphis movement at the start of the 1980s brought postmodernism to furniture.

For Sottsass, there was more than one kind of utility – the emotional variety, as well as the functional. What is new since then is a huge increase in the size of the market for what might be called gallery design. New money poured in to buy Arad, Newson, Sottsass, Ross Lovegrove and Zaha Hadid. Money demands attention. But if this was design as a form of art, then what were the criteria to judge it by? It was obviously 'bad' design measured against the old criteria. But how could anyone tell if it was 'good' art?

The utilitarian argument for design intended for the gallery is to understand it as sharing the theatricality of runway fashion. Flamboyant, unwearable fashion has a symbiotic relationship with the mainstream of the clothing industry and function-free design can be an investment in research and innovation, in the way that the car industry uses concept cars and Formula One to explore new techniques and materials that can later be applied to mass production. Ron Arad is capable of exploiting industrial production to produce brilliantly conceived mass-made objects at the same time as working on spectacular pieces for the gallery system.

It doesn't take much semantic insight to understand the special position that the chair occupies in the infinitely status-conscious world of man-made objects. The chair, and the stool before it, has been around

With the precedent of the Lockheed Lounge sale behind him, Marc Newson has led the market for limited-edition design, priced and sold as if it were art, such as the Voronoi shelves.

for at least three millennia – long enough for it to have assumed an authority of its own, distinct from that of the people who sit in it. In so doing, it has irretrievably confused sign with substance. There are seats of power, country seats, ex cathedra pronouncements, tenured chairs, and of course, chairmen, to say nothing of those occupying hot seats, driving seats, back seats and Cabinet seats. The chair is at heart an object that must be described as being useful, and yet it is also regarded as culturally significant because it has a long history that is so closely associated with so many purposes that go far beyond utility.

The chair, as much as the fireplace, has been an inescapable part of life for such a long time that it has become a cultural – as well as a design – archetype in a way that so many equally useful objects, such as domestic central-heating boilers, have not yet done. A boiler can exhibit as much or more innovation and engineering elegance, and provide all the social insight you need to understand the people who use it, but until it has been around for a lot longer it will not have the same cultural resonances as a chair or a hearth.

After protracted correspondence with Black Rod, I once managed to get to sit on a spare consort throne, designed by August Welby Pugin, for use as a back-up in the Palace of Westminster on state occasions. Out of context, it still looked pretty impressive, even though it had been carefully scaled down so as not to upstage the royal throne itself. It was gilded to look as if it were made of gold, the metal that is still the universal signifier of durability and status in almost every culture. Upholstered in royal velvet, it was equipped with enough Gothic architectural scenery to make anyone occupying it look regal and imposing.

This was both a throne and the symbolic representation of a throne. It was 'real', in the sense that it had been made for the specific purpose of sitting in the legislative chamber of the United Kingdom, and it had been used by 'real' royal consorts. But it was a garment,

something to be worn for the authority it conferred on its wearer, as much as a piece of furniture.

It did not need a real monarch to sit in it to make it look like a real throne. And it was better at making me look like a real consort than I was at stopping it from looking like a real throne by sitting in it.

In the contemporary world, a throne's symbolism is somewhat off target. Throne's have mostly metamorphosed into armchairs. Despots don't make much use of anything called a throne any more. Instead, they encounter each other in chairs wide enough to deal with their inevitably ample girth. They sit side by side, backs to the wall, even if this is a configuration that, unless they start swivelling their heads like spectators at a tennis match, stops them from looking each other in the eye. But at least neither party has to endure the indignity of appearing to be a supplicant to the other while they talk to the TV cameras.

It's no wonder that the history of modern design is so often told as a sequence of relatively high-status chairs, rather than of cars or handguns or typefaces or any other contenders to calibrate the enormous range of possible approaches to design within the parameters of a single type of object. All these, however, can be seen as more functionally useful than the chair, so a chair can be smuggled into a museum to act as an emissary for its more compromised kin. And so many extraordinary objects take the form of chairs that to see them as a microcosm of the world of design is an entirely plausible idea.

Chairs certainly take us through a series of key technological episodes in the evolution of design. After endless centuries in which carving, turning and joining wood defined the parameters of chair design, the pace changed dramatically in the nineteenth century when the Thonet family transformed furniture-making into a fully industrial process. Michael Thonet deskilled furniture-making by investing in machinery and inventing new techniques that could produce complex shapes without depending on craft skills. He used steam bending, and

Pugin and Thonet both played an important part in the development of design in the nineteenth century. Pugin created a national style for industrial Britain, while Thonet industrialized furniture production for the first time, cutting the connection between maker and designer.

modular components, that allowed his heirs to produce one particular model, a café chair known as number 18, by the million since 1876. Thonet and his sons sited a string of factories around the edges of the Austro-Hungarian Empire, to be close to raw materials and sources of low cost labour.

If you were a William Morris, Thonet's patents would have been a development as unwelcome as the McDonald's empire's contribution to nutrition to anyone with an interest in good food. In fact there was nothing about the highly refined, unornamented form of the classic Thonet products that was inherent in the technology that produced them. When the company first showed its bentwood chairs, most of the range attempted to look as much like traditional hand-carved furniture as possible. It was only later that Thonet stripped away all the decorative encrustations and began to work with Viennese architects to produce the first four-legged intimations of modernity.

Marcel Breuer's Wassily Chair, named after his friend and fellow Bauhaus master Kandinsky, took an unfamiliar industrial material, tubular steel, and made it into the personification of domestic modernity.

After bent wood, furniture designers worked with another newly invented material, tubular steel, and then with a huge range of synthetic plastics and glass-reinforced resin, with aluminium casting and plastic and aluminium extrusions, and with rotational moulding. In this sense, the chair is a striking reflection of shifts in technology, production technique and aesthetics – although the most promising technical innovations of recent years, such as gas blow moulding, which allows for the cheap production of sturdy and intricately sculpted forms, have been borrowed from the car-components industry rather than produced for furniture manufacture.

Tubular steel became the emblematic material of the machine age. Marcel Breuer, Mart Stam and Mies van der Rohe – three of the Modern Movement's key figures – all developed their own versions of the cantilevered chair within months of each other at the start of the 1920s. In chair-design terms, tubular steel had the impact of electricity on lighting. It could be bent into tight, springy curves that supplanted the conventional one-leg-at-each-corner format for the chair. There had been technically similar chairs before, devised by anonymous American engineers, but Breuer, Stam and Mies were doing

something else. They wanted to use familiar domestic objects to make a point about the modern world. They might not be able actually to build Utopia. But Stam could at least pay a plumber to knock up something that hinted at what a utopian machine age might one day look like, with the aid of not much more than a few feet of gas pipe.

Marcel Breuer made something much more polished for use at the Bauhaus, while Mies transformed the cantilever into a languid streak of glittering steel, describing a long arc across his travertine-and-glass version of classicism. Eileen Gray celebrated the poetry of mechanisms in her sparely elegant adjustable chairs, lights, tables and mirrors. A generation later, Charles Eames put the lessons of what in the 1940s was regarded as advanced aircraft manufacturing technology to work, and made chairs out of moulded plywood and fibreglass, shaping profiles of birdlike elegance.

Ettore Sottsass was less interested in technique than in form and pattern, and used the chair as the point of departure for a long-drawn-out series of speculations on the nature of ritual, and symbol. These are things traditionally associated with the objects that a society values. Sottsass was one of the first designers to grasp that, beneath the functional alibis, the psychological need for such phenomena still exists in the contemporary world, even if they may take a different form.

All these designers made objects that did much more than address the purely pragmatic question of sitting. Each of their products could be seen as a kind of manifesto for a personal approach to design. And all of the objects produced have a strong case to be regarded as no less emblematic of their times than the art made by their contemporaries. That is why the Museum of Modern Art put Breuer and Mies on show.

Yet, despite their claims to a central place in the history of modern design, neither Gray nor Sottsass was selected for the MoMA's permanent collection, until Gray's gender made her inclusion inevitable. And Sottsass, at the time of this writing, is still represented only by a type-

writer: the rest of his prolific output was seen as running counter to the museum's idea of what constituted design. The more it maintained the fiction that it was interested in mass production as a criterion for its collection, but actually presented design as if it were art, the more MoMA was made to feel uncomfortable by those contemporary designers who, like Sottsass, were genuinely able to make design part of a wider cultural landscape but refused to genuflect to the museum's ideology.

The museum does own an example of Gerrit Rietveld's Red Blue Chair. It's a version that was made in 1923 – the first prototype appeared in 1917, six years earlier – and it is still being made in almost exactly the same form today. Even though it is manufactured in its hundreds rather than millions, by any standards it is a landmark, and not just in the history of modern chair design. It has a lot to say about the uncomfortable scar tissue that divides design from art.

Designed and, in its first incarnation at least, made by Rietveld himself, the chair is an explosion of razor-sharp coloured shards, slicing through a sober geometric cradle that can barely contain them. It is the work of an intense young Dutch carpenter who later became an architect. Contemporary photographs show him in an artisan's smock and bird's-nest haircut, lounging outside his workshop.

The chair was radical in every detail. Its construction, which was based on simple timber dowels, turned its back on the tradition of craftsmanship that celebrated and elaborated handwork. Its aesthetic, its materials and its understanding of the nature of comfort were all new. The Red Blue was made from lacquered plywood and stained beech, finishes that suppress the material qualities of the timber used. There was no applied decoration, no ornament, and no attempt to show off by using precious materials – unless of course you consider the colour to be the ornament, and that the spatial complexity is analogous to using an exotic hardwood. Most challengingly of all, there were no comfort signals: no padding, cushions or superfluous detail.

Rietveld's Red Blue Chair, dating back to 1918, is hardly any less emotionally intense than Mondrian's contemporary canvasses. It's never been proved that Mondrian and Rietveld ever met, but their work clearly had much in common. Yet a chair that Rietveld made for himself will fetch no more than a fraction of the price of a Mondrian painting. Thorsten Veblen's perceptive book *The Theory of the Leisure Class* tells us why. We value the useless above the useful. Art is useless, and even a chair as transgressive as Rietveld's is still overshadowed by the taint of utility.

The chair had been reduced to its bony essence, an intersection of vivid planes of colour. At first sight, it appears entirely unstable, and seems to be an object of uncertain purpose. Furniture is one thing; the Red Blue Chair, which has the appearance of a mechanism through which the human body has been threaded, like newsprint on a roller press, looks like something else.

Though its ostensible purpose was nothing more challenging than keeping its occupant at the appropriate height off the floor, and it was the product of the most basic woodworking tools, its existence seemed to presuppose an entirely different way of looking at the world. It implied a new architectural context and a new approach to space, far removed from even the most progressive of Rietveld's contemporaries. Michael Thonet's patented machines made furniture that was more technically advanced than anything that Rietveld could produce in his workshop. But the Red Blue Chair suggested that the design of domestic furniture was no longer to be understood as a matter of custom and precedent, or of the reflection of status that is implied by so many chairs.

Imagine the impact of putting such an object in almost any house contemporary with its design. In 1917 it would have looked like a visitation from another universe. Even now its power is scarcely diminished. Compared to a railway locomotive, an aircraft or a motor car designed at the same time, it demonstrates the difference between ingenious mechanical objects that could only be the product of the precise moment at which they were conceived and an artefact that floats free of time and place. Its geometry still transforms the spatial qualities of any interior in which it finds itself, while a Model T Ford, so radical and inventive in its day, would look like a frail ghost on a motorway now.

There is nothing any less powerful in the intensity of feeling of the Red Blue Chair than in that of a canvas by Rietveld's con-

temporary Piet Mondrian. Both are the product of a particularly fruitful moment in the development of the culture of the twentieth century. Rietveld wrote in Theo van Doesburg's magazine *De Stijl*, with which both he and Mondrian were associated, 'Our chairs will become the abstract-real artefacts of future interiors.' He had a vision of a new way of life, and of the objects that would make it possible. In the house that he built and, for a time, lived in with Truus Schröder-Schräder in Utrecht, he gave that world an unmistakable physical shape.

Mondrian's paintings amounted to a blueprint for that house, and not just because of the interest in primary colour that he and Rietveld shared. They convey an impression of infinite space and syncopated but rhythmic structure that is closely related to Rietveld's ideas. But do Mondrian's paintings have anything more to say than the house, its contents and the remarkable lives of the individuals who shaped it – lives every trace of which has been obliterated now that the house has been turned into the adjunct of a museum, where visitors are issued with special disposable paper shoes as if they were negotiating a nuclear laboratory?

In the end, despite the eccentricity of its form and structure, and despite MoMA's best efforts, the Red Blue Chair remains to a certain degree stigmatized by the fact of being useful – no matter how slightly – unlike the entirely useless Mondrian painting.

The less than successful counter-attack against the assumption that design is not as significant as art has been based on the suggestion that art has been marginalized since its glory days as a reflection of state power and religious faith. A succession of polemicists has claimed that industrial culture now occupies the central position that art has vacated.

Paraphrasing Roland Barthes, Stephen Bayley, the first director of the Design Museum, used to claim that Michelangelo, were he still

alive, would today be designing cars for Ford, rather than wasting his time carving marble tombs. It's a recurring piece of rhetoric that can be traced back at least as far as the nineteenth-century German critic who suggested that a Jugendstil table by Richard Riemerschmid was superior to the works of Goethe – which produced the wonderfully dismissive response that this was the remark of a man who clearly knew even less about Goethe than he did about tables. And even before that the nineteenth-century American sculptor Horatio Greenough spoke of 'the beauty of purpose made into form'. In his view, 'The men who have taken movement to its most essential form, in the yacht *America*, are closer to Athens today than those who use the Greek temple for every purpose'. Frank Lloyd Wright said much the same in 1901 in his book *The Art and Craft of the Machine*: 'Locomotive engines, engines of war, or steamships take the place works of art took in previous history. Today we have a scientist, or an inventor in the place of a Shakespeare or a Dante.'

There have been continual claims that the real art of the modern world is engineering. But in fact the real art of the modern world has turned out to be art. It has never been more powerful than it is now. Artists have entirely unexpectedly turned into a class of shaman, and have managed to co-opt the techniques of industry to help them do so.

It is precisely the alchemical quality of art that may yet be responsible for transforming it just as radically as the advent of mechanical reproduction that so concerned Walter Benjamin. The unprecedented explosion of wealth that has marked the first decade of the twenty-first century has taken art out of the hands of the curators and the museum directors, even out of the control of the dealers. Collecting is now undertaken with the same implacable machismo as an America's Cup challenge, and the same relentless determination, by the same kind of supremely driven egotists. As a result, contemporary art has become

too expensive for all but the best endowed of museums and galleries to be able to afford to buy.

Rather than wonder about the transferability of Michelangelo's skills to compact car design, perhaps it's more useful to ask if Damien Hirst, with his natural gift for finding publicity's magic bullet, is more like the creative director of an advertising agency than an artist. Certainly the process if not the objectives of making art has come closer to design and manufacturing. An artist such as Jeff Koons maintains a production office. His work is described in specifications and fabrication drawings that are implemented by the production-line workers in his studio, or dispatched to a distant factory in eastern Germany, thousands of miles from his centre of operations in Manhattan. Other artists go as far as China, following the same logic that has driven manufacturing to the low wage economies of the Far East. Marc Quinn's representation of a pregnant Alison Lapper on Trafalgar Square's empty plinth was carved from white marble in a yard in Italy by a team that, according to *The Guardian*'s Charlotte Higgins, who went to take a look, seemed to have honed its somewhat mechanical skills on making large-scale representations of George Bush. In these circumstances, many of the criteria for the success or failure of a work come very close to the values that design depends on. The quality of making, the skill with which joints are formed, and the tactile character of the surface are all key to the impact of the finished object. It's a convergence that has certainly encouraged some to treat design as if it were art. Or at least to price it as if it were.

Art, because of its prestige, is a source of visual ideas that spill into other creative areas. The work of designers in the 1950s clearly took inspiration from the art of their time. Alexander Calder's jewellery and mobiles certainly had an impact on the visual climate, creating a mood that shaped the objects produced during the period.

But at times art also came to be about design – or at least about

Toaster

New, practical, outstanding, this print was made possible by a number of fresh ideas. The proof of the excellence of the toaster that inspired this work of art has been supplied by the results of severe endurance tests recently performed. The appliance was kept working for a total of 1458.3 hours (not counting brief periods for cooling). This was the time taken to toast 50 000 slices of bread. That is a pile of bread well over a quarter of a mile high.
Just how outstanding the design is can be proved by the fact that it has been included among the most attractive objects for everyday use exhibited at the New York Museum of Modern Art – the only automatic toaster in the world to achieve this honour.
White bread, black bread or even rye bread? Ask your friends and neighbours and they will tell you that toast is a first-class delicacy. It tastes good and has never been the cause of anyone losing their driving licence. It keeps you fit and your body needs it.
Printed on Saunders plain mould special printing s/o demi 80.5 lb/500 (complete with Marlerfilm and Marlerflex ink and applied metalized silver polyester) in an edition of 75.
Dimensions 25" wide, 35" high, image area 23" square.

While Warhol celebrated the values of American pop culture, Richard Hamilton's obsession with the much more cerebral attractions of Braun's toasters and toothbrushes were subtler in their understanding of design.

something very like it. After Duchamp became interested in the ready-made, but before Warhol and Jeff Koons, Richard Hamilton was turning a quintessential product of enlightened post-war capitalism, the Braun electric toaster, into the subject matter of a series of art pieces. Art and design serve sometimes to reinforce each other. Pop art's celebration of the surface of the consumer world served as a mirror for certain designers and fed back into the kind of objects that had inspired the art work. Hamilton explored the nature of corporate identity and product archetypes.

The more self-conscious attempts at erasing the gap between art and design have seldom been successful. When Naum Gabo was asked to design a car for a British manufacturer, it got no further than a model. Isamu Noguchi, who designed a whole range of paper lamps and a table for the Knoll furniture company, as well as a Bakelite child-alarm intercom system in the form of a samurai warrior's helmet, found that his sculpture was never fully accepted by the art world, perhaps because he had become tainted by utility. To avoid this happening to them, artists have to go through elaborate doctrinal contortions when they start to work as designers.

Donald Judd got around the problem of defining where art stops and design begins with the aplomb you would expect of a conceptual artist. He simply declared that the two were entirely different, and that they never even get close. When he was making furniture he was a designer, and when he was making art he was an artist, no matter how superficially similar the products of the two categories might look, or how similar the processes involved might be. According to Judd's magisterial pronouncement, they were not the same, and there could be no argument — just as Michael Craig-Martin declared with unshakeable confidence that a glass of water was a tree, because he was an artist and he said it was. Francis Bacon, on the other hand,

Michael Craig-Martin's work of 1973 appears to be a glass of water on a shelf. Craig-Martin, however, asserts that it is in fact an oak tree: as clear a reminder that art has its roots in magic and religion as you could find.

did all he could to play down the significance of the furniture that he designed before he took to painting full-time.

No one has pursued a more nuanced and complex path between design and art, and between utility and uselessness, than Andy Warhol.

When the Benetton family went into the footwear business, in the 1980s, they used Warhol's lifeless image of Giuliana Benetton – from his production line of facile celebrity portraits – as their trademark. That brought Warhol full circle. Thirty years earlier he had been making a good living as an illustrator, churning out spidery renderings of smart footwear for advertisements and catalogues. Now he was back in shoe shops.

In his early career, Warhol was a gifted fashion illustrator. It was only later that he became an artist, commanding attention of a different kind and much higher prices. The fact that his portrait of Giuliana Benetton ended up as the logo for a range of shoes is an irony that cannot have been unintentional.

In between, Warhol had become the most influential artist in the world. His work, so partisan critics claimed, was showing us something new about art in the age of mechanical reproduction. Did the fact that Warhol had become an artist make his trademark for Benetton into something different from his elegant illustrations? Or was it all bluff: was Warhol's deadpan cynicism really a front for something even shallower? We could all love Warhol because he could cheer-

fully tell us what we knew all along: that modern art was a confidence trick. And yet the critics could never be quite sure. Warhol had of course been born of Czechoslovak parents, from a now lost state whose national hero was the Good Soldier Schweik. Was he playing the holy fool like Schweik?

There could not have been a more appropriate owner for Warhol's towering portrait of Mao Tse-tung than Charles Saatchi, a figure just as ambiguous as Warhol. For if Warhol's work is about anything, it is, just like Saatchi's advertising business, about the manipulation of powerful images. Saatchi is the genius of modern advertising who does not speak on the record, and who will not be photographed. Does he own the Mao picture because he likes it, or because he thinks it has something to say about the power of highly charged images, a subject that he is close to himself? Or is he simply hoping to sell it on?

Whatever the reason, it would have been fine with Warhol. He never flinched from addressing the intimate links between culture and commerce. Beyond the irony, he was perfectly open about it. His magazine, *Interview*, recoiled from all forms of editorial intervention. Its journalism took the form of pointing a tape recorder at a subject and transcribing the result. He was unabashed about using the magazine to sell the idea of commissioning a Warhol portrait. He spent his entire career exploring the contradictions between the fetishizing of original images and their mechanical reproduction. Whatever his intentions, he ended up as one of the twentieth century's most potent brand names, with an audience willing to pay for the privilege of owning a Warhol Polaroid, or even a Warhol Xerox.

Warhol began by exploring the icons of popular culture, and ended up by turning himself into one. He was perfectly happy to take a liquor company's money to produce a work that appeared in millions of magazines over the bold headline 'Absolut Warhol'. Indeed, he also endorsed a range of other products, including Pontiac Cars, Pioneer

hi-fi and the investment bankers Drexel Burnham Lambert. The Campbell Soup Company, of course, had his services for nothing.

In his overtly commercial phase, Warhol was simply hiring himself out, selling his services to those companies who wanted to use him in an attempt to change the way that the world saw them or their products. Within months of his death his executor had sold the rights to the Warhol name on a scale that even the artist had not managed in his lifetime. But he had begun with the vastly more radical undertaking of changing the way in which art was perceived by exploring the power of banal commercial images.

Warhol managed to take the subject matter of design and turn it into something else – something with a very different status.

If one takes a purist view, money should have nothing to do with art. The price that a work of art or of design, or even a house, achieves in an auction ought to be a measure of nothing more than the skill of the auctioneer and the dealer in making a market. But, for better or worse, price does go a long way toward creating or reflecting a kind of cultural hierarchy. This phenomenon is itself the subject matter of one of Damien Hirst's more notorious works, *For the Love of God.* Hirst's diamond-studded skull might be seen as a brash inversion of Duchamp's urinal.

In the hierarchy of price, one inescapable comparison is between the sale of one particular Red Blue Chair that Rietveld kept for his own use and the sale of Mondrian's *Composition in White, Blue and Yellow: C.* The chair was auctioned at Phillips in New York on 4 December 2000, with an estimate of $150,000–$250,000. Mondrian's canvas was sold by Christie's in 2003 for $8,071,500. The price reflects the degree of liquidity in the market for such works, as well as precedent and demand. Such canvasses have become one of the tokens that serve to encapsulate the nature of our culture. They are the essential props that any museum of the art of the modern period must collect. Paint-

With his ruthless instinct for finding the jugular vein of publicity, Damien Hirst's *For the Love of God* is a brilliantly cynical and manipulative response to Duchamp's urinal.

ings achieve a certain price level. And chairs belong to an entirely different category of object and price because, despite their historic significance, they still do not enjoy the same status.

In 2007 Christie's in Amsterdam sold an all-white version of the Red Blue that Rietveld made in 1924 for €264,000 – way over the upper estimate of €80,000. If you want a Red Blue Chair in better condition, you could get one factory fresh, smelling of new paint, for $2,000. It costs even less if you don't care about the stamp of authenticity that comes from the Italian manufacturer, Cassina, that claims to have control of the rights to the chair, having signed an agreement with Rietveld's granddaughter in 1971.

Rietveld was interested in creating a new, more accessible approach to design, and in suppressing the subjectivity of the individual maker in favour of a machine aesthetic and, in principle at least, mass production. So it is hard to say which version is closer to his original intentions for the object. Lack of clarity about the way in which such objects are to be understood is increased by the readiness of museums specializing in design to exhibit mass-produced versions. No art museum would exhibit a Mondrian poster as a conceivable substitute for a Mondrian painting. But a design museum is less interested in the idea of the original. And in the world of mass production, how can there be such a thing as a fake?

The inescapable conclusion is that objects that can be categorized as works of design really do carry the burden of utility, and are therefore valued less highly in the cultural hierarchy than the essentially useless category of art. It's a view that bears out the conclusions of Veblen's *The Theory of the Leisure Class*, and his concept of conspicuous consumption. The leisured need to differentiate themselves from those who carry out those tasks that they see as demeaning, and so choose to live and dress in a manner that clearly reflects their freedom from the necessity to work. Veblen describes the adoption and

subsequent abandonment of the corset in just these terms. Since it is all but impossible to do manual labour while wearing one, it was only wealthy women who did not work who could wear corsets when they were first introduced as an item of fashionable dress. Later they became common. The lower middle classes adopted them for Sunday best as the uniform of respectability. And, in reaction, those secure enough to flout the outward signs of conformity promptly abandoned what had become a sign of conventional values.

One of the fundamental ideas of modernism as it is applied to design is that each mass-produced object from a series is the same as every other. They do not and indeed were not intended to have the aura that Walter Benjamin described as an essential characteristic of a work of art. Instead, they offer other consolations: the magical sheen of the machine-made, and the illusion of perfection. But, despite what mass production set out to do and be, it can rapidly take on qualities that are analogous to handcraft. Mass-produced objects become different from each other as they age, and over time they start to acquire an aura, whatever the intentions of their designers.

Price, of course, can have the effect of making a useful object useless. A car or a chair that has been turned from a utilitarian artefact into a collector's piece can quickly become too valuable ever to risk using it in everyday life. Rolf Fehlbaum, who in addition to running Vitra, one of Europe's most innovative furniture companies, is a collector, talks about the paradox of the most valuable furniture pieces in his collection being the failures, the prototypes that never made it into production. In other words, the most useless of the useful are the most valuable. One might also wonder why it is that the most valuable postage stamps are those that have Queen Victoria's head printed upside down, back to front, or in the wrong colour.

An even sharper comparison than the price mismatch between Mondrian's canvas and Rietveld's chair is the gap between the

$250,000 upper estimate on the Rietveld and the $968,000 that was achieved by Sotheby's in New York on 14 July, 2006 for what the auction house described as the prototype for Marc Newson's Lockheed Lounge, made in 1986 and put up for sale by an anonymous Australian collector. It was a price that certainly confirmed the uselessness of the Lounge.

Newson was younger than Rietveld when he made the piece – a curvaceous riveted aluminium skin wrapped around a fibreglass body – in a Sydney surfboard fabricator's shack. Or helped make it. It's striking, but it could hardly be called a mature work, in the light of what Newson went on to do afterwards. Nor will it have the same art-historical impact that the Red Blue Chair did, except perhaps for its price, and that was also a careful, deliberate creation.

Another piece by Newson, a Pod chest of drawers, sold at Sotheby's for $632,000 in December 2006. At the same sale, Ron Arad was the only other living designer to make six figures, while a key piece of work by the well-regarded German designer Konstantin Grcic made less than $10,000, and a prototype by Maarten van Severen, who one might have thought had been helpful by dying young, went for even less.

Why is this? Certainly the fact that Ian Schrager, the inventor of the boutique hotel, parked a Lockheed Lounge in the lobby of the Paramount Hotel in New York for a decade would not have hurt. Nor would the Lockheed Lounge appearance in one of Madonna's music videos. This is glamour by association. Then there is the fact that there is a considerable degree of handcraft in a Newson piece. The Lounge is visibly made in a workshop, and equally visibly it belongs to a tradition that takes in Jacques Ruhlmann and Jean Prouvé, two names whose creations, respectively from the 1920s and the 1950s, already have a well-established track record in the saleroom. Both of them are designers whose work took on a second life, as collector's pieces after they were first made, achieving escalating prices.

And there are only ten Lockheed Lounges in the world, a number that can make even the most sceptical of would-be purchasers reasonably confident about the provenance of what they are buying. Ten plus what Sotheby's referred to as an artist's proof – a concept that was new to furniture design – plus the object in the sale, called a prototype. The artist's proof might best be described as the ex-display model: the one that has been in the sun for a bit, and picked up a few scuff marks. The auctioneer's presentation of the Lounge in these three categories – the prototype, the artist's proof and the edition of ten – also seems to suggest a tripartite hierarchy, reflecting scarcity. The prototype was rare enough to make the anonymous buyer pay almost $1m. And, according to the *International Herald Tribune*, to try unsuccessfully to sell it on just three months later at more than double the price that he paid.

The Newson sale marked the early stages of the creation of a new kind of market, and perhaps a new kind of design. It was something

Marc Newson's surf-shack, sunny Australian sensibility produced the Lockheed Lounge in the 1980s. But it only really established itself as some sort of landmark in the story of design when it was auctioned at a reported price of just under a million dollars, way ahead of anything that Rietveld or Mies ever fetch, a tribute as much to market-making in the auction houses as anything else.

like the moment in the 1980s when photography moved into the museums and galleries and became art. Or at least the work of those photographers who happened to be represented by art dealers did.

When he made the Lockheed Lounge, Newson was one of a number of talented younger designers, struggling to make a living, and there was little to make him stand out from the rest. There is a touch of André Dubreuil and the French decorative arts, crossed with Australian hedonism, in his work. And there was a certain nostalgia for the early days of aircraft, demonstrated by the name. (Art gets titled of course, not named.) Its evocation of the stressed-aluminium skins of the early days of commercial flying is impressive. But Newson was fortunate that his early work was publicized by means of expensively staged publicity photographs that an early client, a Japanese furniture company called Idée, commissioned and distributed to the design magazines of the world. He also had a knowing taste for alternatives to mainstream modernity. It used to be America that obsessed designers. Not Newson. The jet fighter he went joy-riding in as soon as he could afford it had a Russian tricolour painted on the tail fin. He watched Tarkovsky as much as Kubrick. He designed shoes for Nike, and called them Zvezdochka. There was more than a glance to the Trabant in his prototype car for Ford.

Newson's work is a kind of nostalgia for the innocence of modernity as it was seen through the eyes of a society shorn of any intention of seducing the consumer, which it treated with contempt. Ironically, the roots of the kind of bitter-sweet Khrushchev-era modernity that Newson celebrates lie in the American confidence in the future that inspired an earlier generation of designers.

Larry Gagosian, who acted as a dealer for Newson, later claimed that the Lockheed Lounge's $1m price was the highest ever paid for the work of a living designer. It's an assertion that is hard to square with the price tag of, say, an Airbus A380, designed by many people,

When car manufacturers want to give their image a boost without investing in a new production line, they commission concept cars that never get built but attract a lot of attention. Marc Newson speculated about what a Ford could have looked like if the Soviet Sputnik was the last word in modernity.

but certainly a work of design that is beautiful, and beautifully made. Unlike Newson's curious aircraft prototype the Kelvin 40, made for the Fondation Cartier, and later exhibited in the Design Museum, the A380 actually flies. The realization of Newson's somewhat adolescent dream of a personal jet aircraft was a useless object that was for once much less valuable than the very useful Airbus. The Kelvin

could never fly. Constructed from aluminium and carbon fibre, it was closer to an art installation than to industrial design. It involved no structural calculations or fuel-consumption figures. But the fact that it was exhibited in the Fondation Cartier did play an important part in the extended process that was required to turn Newson into a figure whose work could sell as if it were art.

Rietveld did not have a dealer like Gagosian to represent him. During his lifetime, his work was never sold as if he were an artist. Yet it is hard to argue that Newson is a more important figure. And certainly Rietveld's work has greater art-historical significance.

Eileen Gray, Pierre Chareau and Jean Prouvé have all had posthumous careers that moved from the ideal of design as a democratic and accessible medium to the saleroom and the collector's galleries, where scarcity drives up prices. Prouvé made most of his furniture in large production runs, and ran his own factory. Chareau worked closely with metalworkers who made objects that embraced the rhetoric of mass production but used craft skills rather than machines to shape them. In each case the ideology of design claims them as designers, because they had the intention of making mass-produced objects, rather than limited editions. But the chairs that Prouvé manufactured from folded bent metal and which were intended to be as cheap as possible to seat students in university libraries and social security claimants before government offices have become valuable collector's pieces. When they became valuable, dealers started to tear them out of the places they were designed for, and transformed them into precious showroom antiques.

Art creates a language that design responds to. Design also plays its part in creating a visual vocabulary that shapes what artists do. But in the last analysis it is the ability of an artist to question and to be critical that justifies what he does. For a designer to make a critical object is to bite the hand that feeds him. Without commerce, design cannot exist. And yet we now have a generation that produces not just design that aspires to

be art, but even industrial objects that also suggest a certain detachment from materialistic considerations. Phillippe Starck proposes that a gold-plated replica of a Kalashnikov assault rifle is an appropriate ready-made base for a table lamp, and suggests somewhat obscurely, to those who question his taste, that it is a work intended as a piece of criticism.

If this is irony, then it is an irony that is likely to escape the attention of the Chechen warlords or Colombian godfathers who would find it a congenial accessory for their living rooms.

Since design itself is the product of the industrial system, on one level the very idea of a critical dimension in design, and the creation of objects that distance themselves from the system that makes them possible, is a paradoxical proposition. It is as if an advertising campaign could ever truly be critical of the idea of advertising – although there are plenty of people ready to give it a try.

This debate between ideology and utility is in part a reflection of the constant tendency for creative practitioners to seek to migrate up the status scale. Uselessness is, it seems, the most valued quality. So designers aspire to be artists.

In the same way that art so often refers to itself, so design is now growing venerable enough to have developed an extended back story of its own. When Ron Arad was first establishing a reputation, he made design the subject matter of his work, which was itself at some unspecified point between art and design. Even when it first saw the light of day, in 1981, Arad's Rover Chair was never quite as innocent as it seemed. With some bits of Kee Klamp industrial scaffolding, he turned a couple of seats salvaged from a staid but stately British car into saleable new armchairs. These apparently whimsical assemblies were among the earliest products of Arad's career as a designer.

This was the high-tech moment, and the as-found or ready-made aesthetic matched the mood of the time. The salvaged car seats brought something else to the mix, for there was a surreal aspect to

Ron Arad began as a designer using ready-made components to produce furniture, scavenging from scrapyards. His endless inventiveness has made him as much an artist as a designer, giving him the scope to return to the Rover Chair (top), his earliest work, and transform it. The limited-edition version produced in 2007 uses specially made industrial components to replicate what he could only salvage when he started out. Arad's work straddles the gap between art and design; usually not in the same piece but by pursuing parallel careers in mass production and one-offs, such as the Well Tempered Chair (bottom).

their combination with the scaffolding that gave the seat an original sensibility. Another, altogether different, layer to the Rover Chair was its echo of Jean Prouvé's design for an adjustable armchair.

The new Rover Chair that Arad made for Vitra's second edition, a quarter of a century later, is an equally subtle piece of work. The first Rover was what happened when he tried to be an industrial designer without an industry, picking up what he could find to create an approximation of the finish and quality of an industrial object. The new one reflects a shift in the balance of power. Arad now has the clout to be able to work with the level of investment needed to produce industrially made objects that have taken on the status of art. This is the paradoxical situation of a design that was conceived as a bringing together what was most easily available, and therefore accepting the aesthetic of the ready-made, now taking the opposite tack. The new version is an evocation of the original, but refracted through the perspective of industrial production.

But then paradox is at the heart of Arad's work. He was invited to design a piece for the first Vitra Edition in 1986. It turned out to be the Well Tempered Chair, a springy piece of steel fastened into tight curves by a series of wing nuts. And it was, as Ron Arad told me, a failure. 'I was confronted with mass production, and I simply couldn't think of anything to deal with it. The Well Tempered Chair has nothing to do with what Vitra was capable of. It was a one-off.'

The new limited-edition Rover reflects the evolution of Arad himself, and also of the world of design. It's a project that is intended to look at both industrial production and the limited edition. But both versions are a kind of laying to rest, or completion, of a process that started a long time ago. The challenge with the new Rover Chair, as might be said of a new Mini, is to maintain the essence of the quirky charm of the original, but to make it in a modern way that is of its own time, rather than a parody or a copy.

In its industrial version, the new chair has carefully shaped steel tubes, and elegant specially made castings rather than crude but effective Kee Klamp connectors. There are two versions of the limited edition. One is in rusting Corten steel; the other is in chromed milled steel. The new Rover is different from the original but the same – still an object that is far from innocent, despite its charm.

Such limited-edition works have yet to be comfortably digested by the mainstream world of design. Paola Antonelli, the curator responsible for design at the Museum of Modern Art, who put on Arad's first show there, maintains that there is something questionable about the idea of design that does not have at least the ambition of mass production. So for her it is permissible to allow Arad into the museum only if she can detect the intention for his work to be understood as design, to be produced in multiples.

But Arad refuses to be tied down in this way. At different times, but also simultaneously, he works as a designer and as an architect, and it has to be said as an artist. Was he, despite all the evidence to the contrary, actually intending all his twisted-metal chairs for mass production? And if so, how could she tell?

Arad has explored how to make large numbers of things cheaply, once the investment has been made in the production tools, and also the making of very small numbers of expensive objects. The latter need to be able to command high prices to reflect the investment in the time of the highly skilled craftsmen on which they depend.

Arad is driven by cultural ambition rather than by a business model in the way that, for example, James Dyson was when he hit on the vacuum cleaner as the vehicle to propel his business. It was, he recognized, the kind of consumer item that was just at the top end of affordability for the average purchaser before they had to consider credit terms. Arad survived as a designer by inventing a new definition of design for himself.

We live in a time when our relationship with our possessions is undergoing a radical transformation.

Design has been used to engineer desire since it first emerged as a distinct profession. It was about the separation of shaping from making. But with the appearance of the work of Marc Newson or Ross Lovegrove or Ron Arad in art galleries, some kind of transgressive line has been crossed. The ideology of design has been intimately bound up with problem-solving. Now we are being offered an entirely different category of object. It is not one that is likely to do much in the short term to shift the relative positions in the social hierarchy of art and design. What it will do is fuel what may be a short-lived explosion of flamboyant new work.

E P I L O G U E

THE END STARTED IN SUCH SLOW MOTION THAT IT TOOK A WHILE
to understand that anything serious was going on. In Munich
one Friday early in August 2008, over lunch in a sleek restaurant that
served traditional Bavarian cuisine in such a way as not to scare off
those with a suspicion of white sausages, it began to strike home to
a group of curators, gathered to talk over the place of contemporary
design in museums, that a decade of fin de siècle irrational exuber-
ance was on the verge of imploding. The room was a carefully pre-
served slice of early nineteenth-century stonework, transplanted into
a striking plateglass-fronted cavern in a city centre shopping mall.
It was surrounded by the fleeting consolations of shops stocked with
leather satchels rustling with tissue paper, and costly pens wrapped
in chamois leather. I remember noticing the carefully understated
$1500 bag made by Hermès that one of my companions had under her
seat. The aggressive branding that once characterised such objects
had given way to subtly stitched leather handles and dusty pink

canvas. These were still the kind of things that seemed important to a personal sense of self-worth at the time. I wanted to buy one, even though the thought of such a brutal amount of money for something that a plastic shopping bag could do equally well felt like a deliberate act of self-harm.

As the coffee came, somebody looked at his Blackberry. The Dow it seemed had fallen by 400 points. The Federal Reserve and the governments of Britain, France and Germany were pumping billions of dollars into financial markets as they found themselves impotent to overcome the stubborn unwillingness, born of fear, of the banks to lend to one another. We looked at each other for a minute, and then the conversation moved on. The credit crunch had arrived, and yet nothing really seemed to be happening. My American Express card still worked to pay the bill. If I had tried to buy my house that weekend, it would still have cost me three times what I had paid for it five years earlier, and I would have been unlikely to be asked to prove that I could afford the mortgage. The idea that in less than twelve months I would be calling up the finance director at the Design Museum to ask him where he was keeping our money for fear that it was about to vanish into a digital black hole would have seemed the stuff of lurid dreams.

At Lehman Brothers, regional managing partners went on with their plans to rent the usual house in the Hamptons. Ian Schrager was putting the finishing touches to 40 Bond, his development designed by the architects of Beijing's Olympic stadium that was turning a derelict street in the Bowery into desirable real estate. Michael Peters, the first graphic designer in Britain to float his business on the stock exchange, back in 1983, and to go bust not long afterwards, was busy. He was working in Reykjavik on a new online identity for an Icelandic financial services company. He came up with a clever name: Icesave. It offered a full percentage point in interest above its on-shore competitors for savings. Peters' job was, as he describes it, to reassure those

nervous about putting their money in an overseas bank. In his book, *Yes Logo*, Peters calls Icesave 'the future'. In words that will no doubt come to haunt him, he claimed: 'It became clear through the research that the naturalness, purity and perceived simplicity of Iceland was a key factor in the development of the name.'

The naturalness and purity of Peters' work was persuasive enough to convince 300,000 Britons to entrust £4 billion of their savings to Icesave, their doubts laid to rest by the freshness of Peters' typography – unfussy Helvetica, rendered in fruit-flavoured popsicle colours that seemed to say fresh, modern and honest, and so reliable and competent. In the autumn of 2008, when the fundamental implausibility of a nation of 300,000 people, with no more than cod and geothermal energy to keep them afloat, hosting a banking sector with international reach became too glaringly apparent to ignore, the British government invoked the provisions of its antiterrorism laws to freeze any Icelandic assets still within their reach to ensure that those savers got their money back.

While I was writing the first draft of this book – and beginning to sound like that fifteenth-century fanatic, Savanarola, calling for a bonfire of the vanities in Renaissance Florence – all this was still some way off. Car makers were still a long way from closing factories for a full month over Christmas. (A move of course that could have repercussions far more threatening for the hourly-paid assembly line teams than for those who were to end up handing in the keys of the Bentley on which they could not keep up finance payments.) *Vogue* was still 800 pages thick on the basis of its advertising. HSBC's private banking arm was honouring its commitment to sponsor the annual Art Basel/Miami jamboree, and Damien Hirst's staff was working flat out to prepare for his unprecedented auction sale, while Hirst himself went bear shooting with a Ukranian oligarch with a taste for contemporary art. A year later all

that was solid was melting into air, and Hirst was laying off his assistants.

Now, as with the sudden disappearance of Art Nouveau in the early part of the twentieth century after 15 years of world domination, we will see a radical shift. After excess comes sobriety. In the years after World War I it was machine-age modernity that reshaped visual culture. Now, driven by our guilty carbon footprints, our disgust at the activities of corrupt fund managers, and the absurdity of competitive yacht building, conspicuous consumption is going to take a backseat for a while. Some designers are already beginning to express their regrets at the wave of limited editions they were involved with. They will certainly be talking about craft skills, and ways to recapture memories and emotional interaction on a more profound level. Some of the most interesting work will take place not in shaping objects, but in coming to terms with the immaterial varieties of design that exist in the digital world. However, as the Icesave story shows, the screen can be used to much the same cynically manipulative ends.

I am still fascinated by the process of design, and the window it offers in understanding the world. Yet it makes us susceptible to the same difficulties that we suffer in our relationship with food and alcohol, oscillating between binge and extreme self-denial. The natural emotional relationship we look for with everyday things opens the way to a self-destructive narcotic addiction. The simple pleasure of the possession of a familiar, well-crafted artefact is perverted to become a variety of substance abuse. We find ourselves seduced into constantly searching for the fleeting high of a new possession, a new purchase, and a fascination with the new.

This will not go away through the collapse of the market but it will make it harder for most of us to get our fix. It may bring an abrupt end to a tidal wave of pointless overproduction. Yet of course no government, even in Iceland (which saw the value of its currency halved

in a week, leaving not enough foreign exchange to import fresh vegetables and medicines), can afford to see us do away entirely with the impulse to engineer desire. We find ourselves exactly at the point that Earnest Elmo Calkins was at 80 years ago, when he pointed out that it was the patriotic duty of all of us to consume our way out of the Great Depression.

SOURCES OF QUOTATIONS

Earnest Elmo Calkins first used the term 'consumer engineering' in a lecture, then contributed a foreword to *Consumer Engineering: A New Technique for Prosperity* published in 1932.

Philippe Starck is a designer with an indefatigable appetite for self-publicity. Most of the words attributed to him in this book come either from conversations with the author, or from the numerous interviews that he has given over the years to many specialist magazines and newspapers, or from notes transcribed from the soundtrack that he recorded for his monographic exhibtion at the Pompidou Centre in Paris in 2001.

p. 11, Jean Baudrillard: from *The System of Objects*, translated by James Benedict, published by Verso in 2005.

pp. 90–91, Thorsten Veblen: from *The Theory of the Leisure Class*, first published in 1899.

pp. 100, 101–102, Josef Hoffmann: The manifesto of The Wiener Werkstätte, known as the *Work Programme of the Wiener Werkstätte*, was

written by Josef Hoffmann with Koloman Moser in 1905. It is reproduced in *Design in Vienna: Wiener Werkstätte 1903–32*, edited by Werner Schweiger and published by Thames and Hudson in 1984.

pp. 103–104, Adolf Loos: The best source in English for the writings of Adolf Loos are the two volumes published by the Ariadne Press. *Ornament and Crime* (1997) has the text of the essay of the same name, which dates from 1908 and was given in various forms as a lecture. The second volume, *On Architecture*, was published in 2007.

p. 151, Alan Bowness: as reported by Stephen Bayley in the *Observer*. In a subsequent interview with this author, Bayley conceded that these may not have been the exact words used by Bowness.

p. 152, George Nelson: from 'Both Fish and Fowl', George Nelson's 1934 article for *Fortune*, which explored his view of the designer's role in the depression years. An anthology of Nelson's writings was published under the title *Problems of Design* in 1957.

p. 155, Arthur Drexler: from *Introduction to 20th Century Design*, published by MoMA in 1959.

p. 168, Gerrit Rietveld: what was to become Rietveld's Red Blue Chair was published for the first time in the September 1919 issue of *De Stijl* magazine.

p. 169, Horatio Greenough: from *Form and Function: Remarks on Art*, an anthology of writing, first published in 1946, by the American sculptor, who died in 1852.

p. 169, Frank Lloyd Wright: from 'The Art and Craft of the Machine', a lecture that Wright delivered on several occasions from 1901 onwards. A version is reprinted in *America Builds*, edited by Leland Roth and published by Harper and Row in 1983.

PICTURE ACKNOWLEDGEMENTS

Grateful acknowledgement is given to the following for permission to reproduce images:

pp. 16 (*top*), 35 – copyright © Jennie Hills/Penguin; p. 16 (*bottom*) – copyright © Mauritius Images; p. 21 – copyright © Christie's; pp. 24 (*top* and *bottom*), 60, 72, 87 (*bottom*), 101 – copyright © V & A Images, Victoria and Albert Museum; p. 27 – copyright © Time & Life Pictures/Getty Images; p. 29 – copyright © Philippe Starck; p. 33 (*left*) – copyright © Frank Bohm; p. 33 (*right*) – copyright © Penguin Books; p. 36– copyright © Plexi/Photofest; p. 38 – copyright © Nick Waplington; p. 39 – Citroën Archive; pp. 40, 142 – copyright © Bettmann/CORBIS; p. 42 (*top*) – copyright © Dennis Images/ Richard Dredge; p. 42 (*bottom*) – copyright © Motoring Picture Library; pp. 43, 162 (*right*), 163, 166 (*bottom*) – copyright © The Museum of Modern Art, New York/Scala, Florence; p. 50 – copyright © DK Images; p. 53 (*top*) – copyright © Dennis Images/John Colley; pp. 53 (*bottom*), 69 – copyright © Science Museum/SSPL; p. 56 – copyright © British Motor Industry Heritage Trust; p. 61 (*top*)

– copyright © Interfoto/Hermann Historica GmbH; p. 61 (*bottom*) – copyright © Car Photo Library; p. 64 (*top*) – copyright © Paul Rapson / Alamy; p. 64 (*bottom*) – copyright © Eye-Stock / Alamy; p. 65 (*top*) – copyright © Visions of America, LLC / Alamy; p. 65 (*bottom*) – copyright © Kolvenbach / Alamy; p. 72 (*right*) – copyright © Philadelphia Museum of Art/CORBIS; pp. 83, 93, 143 – copyright © Getty Images; p. 87 (*top*) – copyright © Sotheby's; p. 89 – copyright © United Artists/The Kobal Collection; p. 96 – copyright © Mark Lennihan/AP/PA Photos; p. 97 – copyright © The House Book, Mitchell Beazley and Conran & Partners, image courtesy of the V&A; p. 106 – copyright © Calvin Farley; p. 109 (*top*) – copyright © Bentley Motors Limited; p. 109 (*bottom*) – copyright © Drive Images / Alamy; p. 117 (*top* and *bottom*) – copyright © Richard Bryant/ Arcaid; p. 120 – copyright © Rex Features; pp. 121, 124 (*top* and *bottom*) – Image Courtesy of The Advertising Archives; pp. 126–27 – courtesy Monika Sprüth Galerie, Köln/VG Bild-Kunst, Bonn/ DACS, London 2008; pp. 128–29 – copyright © Thomas Brown; pp. 136 (*top*), 137 (*bottom*) – copyright © Hardy Blechman collection/ courtesy of DPM ISBN 0-9543404-0-X; p. 136 (*bottom*) – copyright © Natick Soldier Center/courtesy of DPM ISBN 0-9543404-0-X; p. 137 (*top*) – copyright © Steve Grammont collection/courtesy of DPM ISBN 0-9543404-0-X; p. 139 – copyright © Andre Roberge; p. 145 – copyright © Michel Arnaud/CORBIS; p. 153 (*left*) – copyright © Succession Marcel Duchamp/ADAGP, Paris and DACS, London 2008, image courtesy of Tate Images; pp. 153 (*right*), 175 – copyright © Andy Warhol Foundation/Corbis; p. 157 – copyright © James Leynse/Corbis; pp. 159 – copyright © Lamay Photo/Marc Newson Ltd, courtesy Gagosian Gallery, New York; p. 162 (*left*) – copyright © National Heritage Memorial Fund/ V&A; p. 166 (*top*) – copyright © 2008 Mondrian/Holtzman Trust c/o HCR International Warrenton, VA; p. 171 – copyright © Richard Hamilton, all rights reserved, DACS 2008; p. 173 – copyright © Michael Craig-Martin; p. 174 – copyright © 2008 Andy Warhol Foundation for the Visual

Arts / Artists Rights Society (ARS), New York / DACS, London. Image courtesy of Benetton; p. 178 – copyright © Damien Hirst, all rights reserved, DACS 2008; p. 182 – copyright © Carin Katt/Marc Newson Ltd; p. 184 – copyright © Tom Vack/Marc Newson Ltd; p. 187 (*top* and *bottom*) – copyright © Ron Arad Associates.

INDEX

References to pictures are given in *italics*.

3 1901 04603 7430